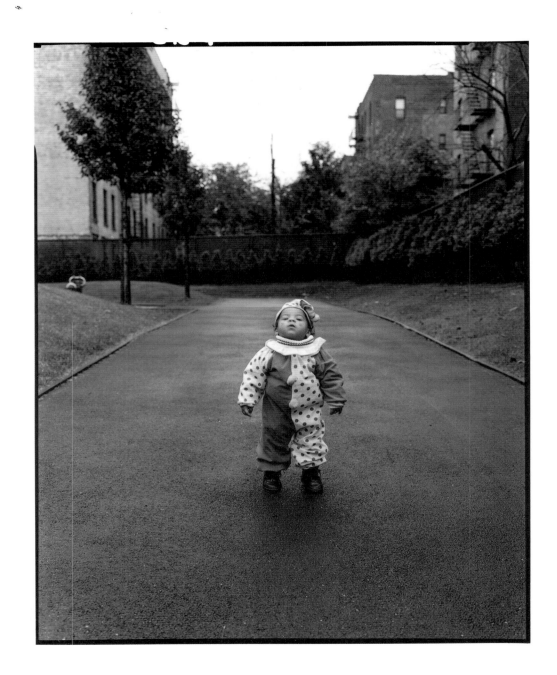

A Cry for Help

Stories of Homelessness and Hope

PHOTOGRAPHS BY MARY ELLEN MARK

Introduction by Andrew Cuomo

Preface by Robert Coles

Interviews reported by Victoria Kohn

Umbra Editions

A Touchstone Book

Published by Simon & Schuster

New York London Toronto Sydney Tokyo Singapore

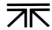

TOUCHSTONE
Rockefeller Center
1230 Avenue of the Americas
New York, N Y 10020

Designed by Tony Morgan, Step Graphics, New York
Manufactured in Hong Kong by Palace Press International

10 9 8 7 6 5 4 3 2 1

Nan Richardson and Catherine Chermayeff, Editors
Grace Madden and Fara Hain, Assistant Editors

An Umbra Editions Book
Umbra Editions
180 Varick Street
New York, New York 10014

Library of Congress Cataloging-in-Publication Data
Mark, Mary Ellen, 1940-
 A cry for help : stories of homelessness / photographs by Mary Ellen Mark ; introduction by Andrew Cuomo ; preface by Robert Coles.
 p. cm.
 "An Umbra editions book."
 "A Touchstone book.
 1. Homeless persons — New York, New York — Case studies.
2. Homeless persons — New York, New York — Pictorial works.
3. Homeless children — New York, New York — Case studies.
2. Homeless children — New York, New York — Pictorial works.
I. Title.
HV4506. B67M3Z 1996 95-43651
382.5' 09744'61—dc20 CIP

ISBN: 0-684-82593-7 (pbk.)

Front cover: Jaime Molina and Teresita Ortiz
Frontispiece: Kelly Flores
Back cover: Andrews "Buddha" Morrison

DEDICATION

The messages on the pages that follow are from families and children in need of safe homes. Some lost their homes to fire, others lost their jobs. Too many mothers and children are fleeing their batterers. Many suffer from physical disabilities, HIV/AIDS, mental health problems, and alcohol or substance abuse. They are children, men, women, white, black, Asian, Latino. All in hope of a secure job, an opportunity for independence. All our neighbors.

Look at their faces and hear their voices call for help.

The H.E.L.P. organization dedicates this moving collection to the thousands of homeless families we have served at our residences. Thank you for sharing your personal stories of hope which have become our inspiration and lessons in courage.

RuthAnn Krafve

When you lose your home, you have lost everything; you don't have anything. I had to go into a hospital when I had my son. After, I had nowhere to go — I had no choice but to come to a shelter.

When I was little, we moved around a lot, because my father drank a lot. I lived in a motel with my parents when I was young. It was dirty, it was small. It wasn't a good place. I wouldn't want my kids there. It was horrible.

And so when I got out of this hospital, I didn't know where I was going to go or anything. I didn't know what was going to happen. I moved into a one-bedroom house. But then it burned down. When I got here I was shocked — this was a chance for me to make my life better.

And I want to make it better. I want to go back to school. I want my kids to have more than what I had. I want to be able to purchase a house one day, and a car. I want them to have nice things, and for them be able to go to college.

That's what I want.

Leaving for a new home, Bronx, New York

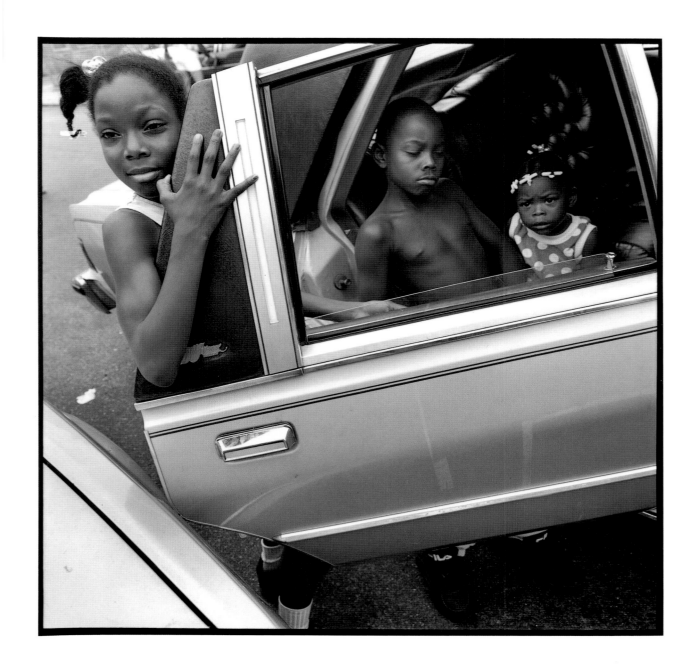

Introduction

Today America stands at a crossroads. The path we choose will determine the future of our country, the well-being of our people, and the state of our nation.

For many years, our urban centers have been suffering from persistent social and economic problems, among them racial tension, an aging infrastructure, and the flight to the suburbs. Now these conditions are being aggravated by the new set of challenges presented by the global economy and the information revolution. And computers and faxes now make the suburbs a viable workplace alternative to the nation's cities.

Compounding these problems are the current Congress's efforts to slash funding for mass transit, housing, social services, education, job training, and health care. While these services are important to everyone in America, they are critically important to the poor in their struggle to achieve and maintain self-sufficiency. Ultimately these cuts can only lead to a diminished quality of life for all of us. But they are particularly harsh for those with special needs, who require government assistance to stabilize everyday living. Local governments now shouldering the responsibility for these citizens alone, without federal help, will inevitably be forced to raise taxes even higher. This in turn will hasten the exodus of the middle class and businesses from our cities.

Why are Americans angry at government's inability to solve the problem of dependence? The stark truth is that the political climate reflects a lack of confidence in government's capacity to change things. The current thinking of "the less government the better" is not without cause. The past three decades have seen government promises and resulting programs generate bureaucracy and cost to tax payers — with few results and visible differences. Rigid bureaucracy, hierarchical management, and an institutional lack of appreciation for individual responsibility all contribute to failed social policy. The genesis and development of homelessness as a social blight in the United States is a painful example of these factors.

The problem of large-scale homelessness first began to appear in urban areas in the early 1980s. The immediate response, both by government and charitable institutions, was to help the homeless by developing emergency "shelters." That vaunted solution quickly proved misguided. By 1992, New York City was spending more than $200

million per year from its operating budget to deal with homelessness, and nearly $2 billion in government funds had been directed to the problem of New Yorkers without homes. In spite of these efforts, homeless adults continued to inhabit parks, train stations, and other public places. The flow of adults and children into the shelter system continued unabated. Even the cost of a simple cot had reached an unbelievable $18,000 per year.

In the past ten years, church basements, armories, and hotels were converted into little more than expensive holding areas for the homeless. While people received "free" shelter, little assistance was given to them to overcome the underlying problems that caused them to be homeless. In fact, virtually no attention was given to actually analyzing and understanding the factors contributing to homelessness.

While homelessness and poverty had always been with us in one form or another, the 1980s revealed that a new type of homelessness had emerged, and with it a dramatic change in the affected population. This new population, which was growing rapidly, consisted largely of single young men and young women with children. Neither government nor private social service agencies were equipped to respond to this phenomenon.

As the numbers of homeless grew, the public became increasingly aware of the systemic failure to respond to the problem. The expanded use of welfare hotels and armories came to symbolize the inadequacy and inhumanity of the government's response. The plight of the homeless, and particularly of homeless families and children, provoked mounting criticism of the government's efforts.

It was in response to this crisis that Housing Enterprise for the Less Privileged was born. The H.E.L.P. model was designed to help people help themselves, by providing a safe and humane environment that empowered families to stabilize themselves and pursue self-sufficiency. H.E.L.P. recognized that homelessness is most often caused by significant health, social, and economic factors, such as the lack of education, few employment opportunities, substance abuse, and domestic violence.

H.E.L.P. determined that the way to confront these endemic problems was by first directly assessing individual needs. It also provided the opportunity for families to gain independence by making available educational and vocational services and quality day care. The H.E.L.P. model is based on the philosophy that government should not be in the business of developing housing or delivering social services. While government cannot and should not avoid responsibility for funding necessary housing and other social programs, the actual construction and operation of these programs is best left to not-for-profit organizations expert at meeting the needs of disenfranchised populations. As H.E.L.P. enters its tenth year of operation, it's success is evident. It is cost effective, and it invests in our greatest resource and asset — our people.

Investing in Americans is indeed the key to confronting homelessness. To this end, President Clinton has introduced an empowerment initiative on a national level that proposes a radically different attack on the problems faced by our nation's poor and distressed communities. The President's approach relies on individual responsibility, community governance, economic opportunity, and public–private sector partnerships. This initiative begins by designating empowerment zones and enterprise communities — targeted areas in cities and rural communities that receive substantial federal resources and tax incentives to implement strategic economic and social community revitalization plans. This socially aggressive yet fiscally conservative program already shows early signs of success. Yet, the skepticism toward government solutions, built up over decades, remains high.

Over the past two years, I have traveled the country extensively. I have found that the American people, living in both urban and rural areas, do want to reach out to those in need and work together to solve our problems. But they are deeply doubtful that either individuals or institutions can actually make a difference. Examples of programs and models that have been proven to work, like H.E.L.P., can deflect this growing cynicism. They can also reaffirm our humanity and faith in one another. Feeling that we are part of a larger community and working together with that community to provide the opportunity for people to improve their lives is an unbeatable combination. It is this kind of cooperation that is crucial in defining the quality of life of the future for all of us.

Andrew Cuomo
September 1995
Washington, D.C.

Israel Vargas and Luis Munoz

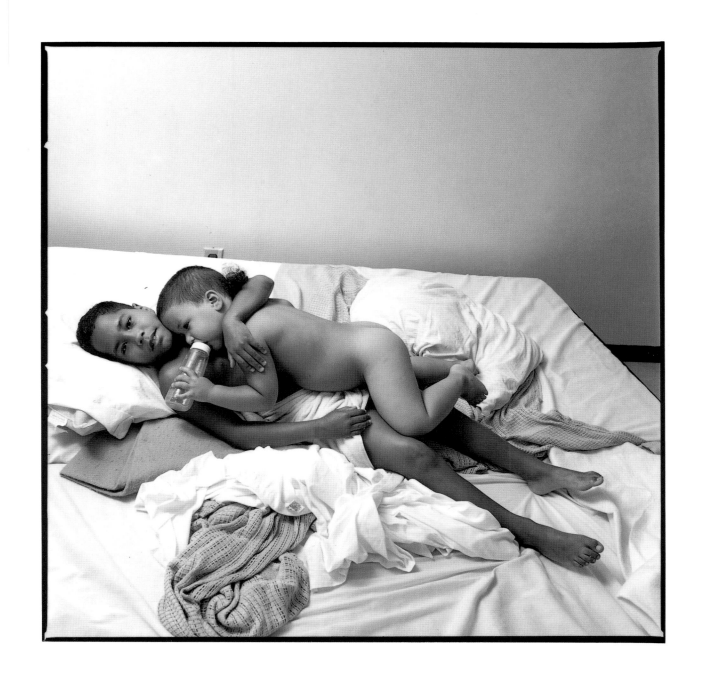

PREFACE

During the autumn of 1987 and the winter of 1988, I spent time with children who were described by social workers in Boston as "homeless;" that is to say, whose families had no place they called their own, and consequently had turned to the city and its representatives for whatever assistance was possible. Usually, access to so-called "shelters" was limited; "temporary residence" meant an indeterminate length of time that could stretch from days, to weeks, to months. Meanwhile the hope was that something would happen — a lucky invitation from a relative or a friend to share an apartment, a successful placement in a subsidized housing project, a reluctant agreement of a family member to take in kin, at least for a while. Day after day I heard boys and girls of seven or eight (or younger, or older) talk of their worries and fears, their hopes and yearnings. Each time I talked with those children I also asked them to draw or paint pictures. I asked them to show me and others where they expected to live in the near future, where they now lived, and, of course, where they would like to live, if good luck came their way.

I will always remember some of those drawings and paintings, the trouble those children had in doing what other children can do with ease and pleasure: represent on paper a sturdy, attractive, inviting house, firmly located on land under a sunny, beckoning sky. In contrast, these children of homeless families weren't able to imagine a fate different from their own. They could not conceive of living in a home that is *there*, solid and reliably secure in the face of time. Again and again I was offered pictures of fragile, ramshackled buildings that didn't quite hold together and that seemed vulnerable, threatened by drenching rains falling from darkly clouded skies or by towering poles or trees that loomed menacingly over loosely attached roofs. These children often put no ground under the houses they drew — their way of indicating how up in the air their lives are, how roofless and uncertain. Gradually, I came to realize how adrift these boys and girls felt, cut off psychologically because of their social or economic situation as the children of homeless parents. One girl observed me noticing the house she had drawn — its slapdash quality, its lack of connection to the natural world (land, grass, trees, sky) — and she read my thoughts. "I was trying to think of a house we could find, and stay there, but I couldn't; so, I just drew that — in a hurry," she volunteered. "When we find a place and we can stay in it, I'll do a better job [at drawing] maybe."

Such an explanation tells so very much. It reminds us that a child of eleven is quite capable of understanding the precariousness of her life, and quite capable, too, of realizing the fall-out such a state of affairs can have. This young girl intuited that life as an artist cannot easily be separated from life as a member of a homeless family that has no reason to feel hopeful. She was in such a hurry to draw, she took little care as she drew, she was ready to toss the drawing in the wastebasket — because she understood quite well how unsettled and transient her family's life had come to be and how far from any emotional truth her picture therefore was.

Not that the children I met (or the children who appear in the pages that follow) need crayons to express indirectly and symbolically their sense of what homelessness means for them and their families. Many times I heard boys and girls of elementary school age wonder out loud when they would finally find a bedroom, as one boy put it, "that won't go away." At seven he had already lived in more places than he could either count or remember. He had already come to expect any place where he currently lived soon to disappear. Employing a child's logic, when he did move into a new apartment with his family he started counting the days, in the hope that he'd amass so many days that he'd be able to stay put. "If we keep living in a place, we might just stay there," he reasoned. "If we stay a hundred days, that's a lot. If we stay two hundred days, that's a sign that we're supposed to stop moving around." I asked him to explain himself — a sign from whom? He hesitated, shook his head, and said he wasn't sure: "Just a sign." But he had been given pause, and he wanted to reflect on his own assumptions. Looking out the window toward a block of apartment houses across the street from the "temporary shelter" where we sat, he spoke again. "The people there [he pointed] don't count the days. They just stay there, as long as they want. I see them coming in and out and I think they're sure as lucky as you can get. Maybe we'll get lucky, too. I count forward and I count backward, and on Sundays, when the week starts, I show my mom what the number is."

At work in this ten-year-old's mind was an attempt — through magic, really — to gain some leverage over a fate that seemed inscrutable, harsh, relentless and unforgiving. We all have our secret (and not so secret) flirtations with such magic — when we place our bets and conjure up the fantasies we hope will bring us this or that kind of success. This child was playing his own kind of numbers game, letting his mind bargain ingeniously and keeping tabs constantly in hopes that his roulette wheel kind of existence would somehow become a more reliable, fixed, unchanging life.

This is what homelessness ultimately does to children — and to all of us. Putting the mind in a kind of imprisoned jeopardy, it binds the intellectual, emotional, and moral life of a person, so that he or she has less and less time for ordinary concerns. Just as a hungry person can't stop thinking about food, so someone without a home, moving

from place to place with no roof to take for granted, will keep thinking and wondering and worrying about buildings, places, durations of stay, about permanence or impermanence, about life itself, with its grim reality, its questionable possibilities.

A book such as this is meant to bring its readers closer to the minds and hearts of those who figure in the photographs, and by extension, to the thousands and thousands of others, across this land, who share a similar fate. Here we all are, citizens of the world's richest, strongest nation, alive in the last years of the twentieth century, just a few years short of the third millennium. This moment in time will mark the arrival of a great teacher and healer who came on this earth with message of charity and kindness. Yet, among us are fellow citizens, neighbors (in the spiritual sense of that word) whose needs are painfully obvious, even as all-too-many of us avert our eyes from them. The callousness and moral indifference that the Hebrew prophets decried and that Jesus of Nazareth confronted, are (like the poor) still among us. We can only hope that in a fitting gesture to the fast-approaching year 2000, this nation will prove itself worthy of the Golden Rule that urges us to respond to others as we would want those others to treat us. So doing, so being, we can find a way to look with respect at one another, find ways for those among us living at the very edge, without even the assurance of a roof over their heads, to come closer, and to join the "beloved community" that counts food and shelter as utterly necessary mainstays for every single one of its members.

Robert Coles
August 1995
Cambridge, Massachusetts

Katiyah Sutten and Anthony Garrett, Astoria Pool, Bronx

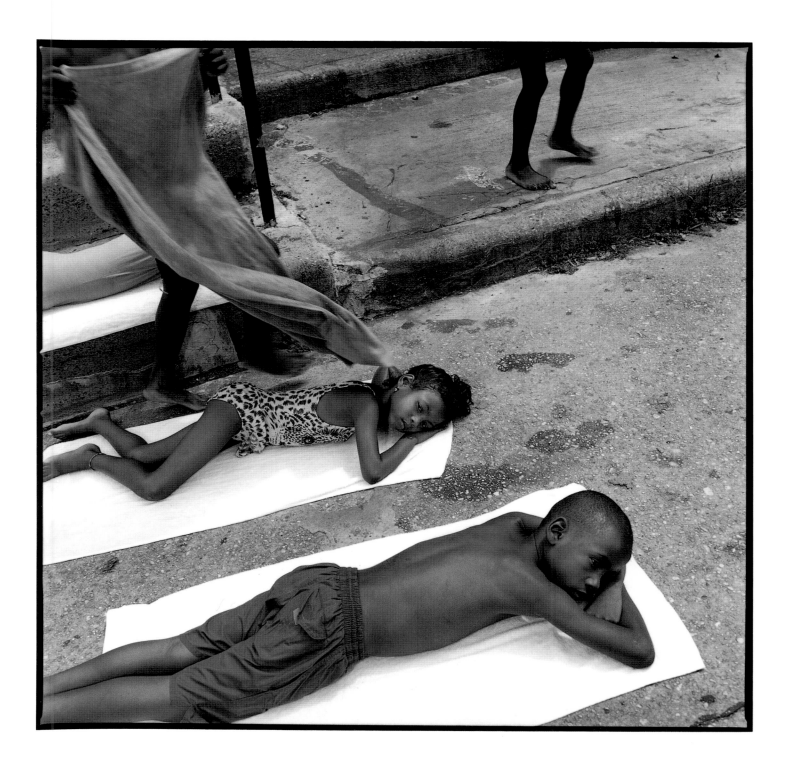

Shanáe Vaughn Palmer

I'm five. It's my birthday. I wish I was ten.
I have two favorite dolls. One's name is Mermaid.
I'm going to play now.

Shanáe Vaughn Palmer and friend

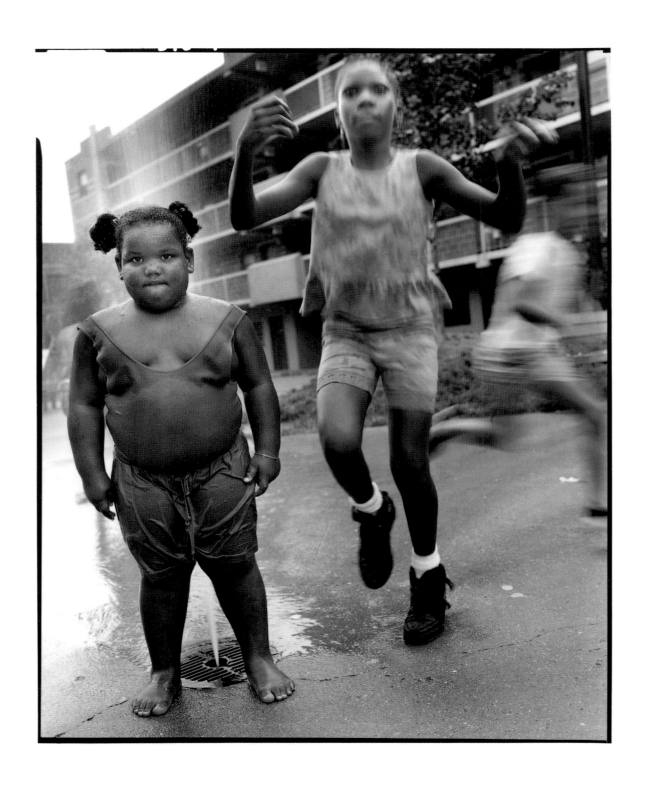

Andrews "Buddha" Morrison and Dwana Morrison

Buddha: I sweat by myself. I'm a big baby. I got a green bottle and a red bottle.
Someone hit me, and I hit him back. His name is Jose.

Dwana: He was real, real fat when he was small. That's why we called him Buddha. He's a Grandma's man.
You gotta act like a little gentleman if you wanna be a star.

Andrews "Buddha" Morrison

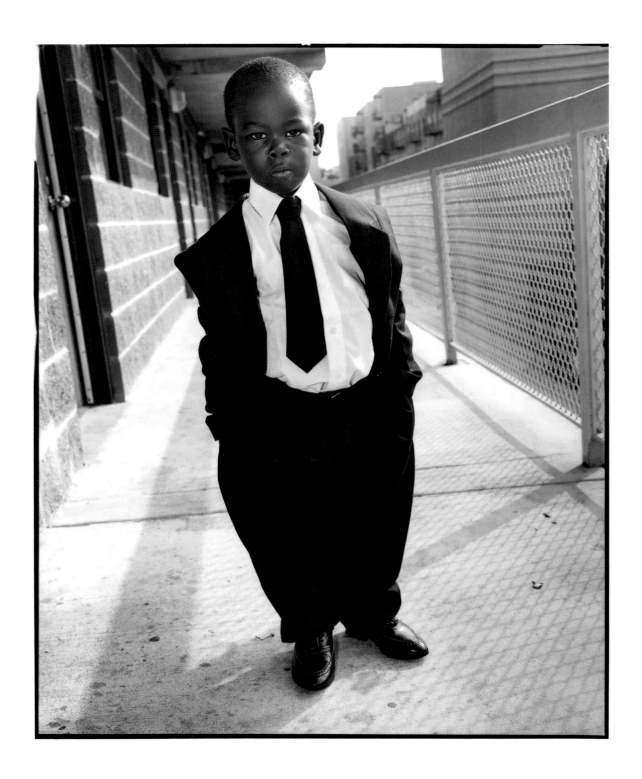

Zuvil Santos and Jessica Sanchez

Zuvil: We were in a shelter on Catherine Street. The first day there a security guard was stabbed. It was terrible. There were terrible people there. It's especially hard on the children. I had Pablo at sixteen. Their father left when Jessica was four. Jessica has a seizure disorder, and, well, he couldn't handle it. I have to do everything. But then I couldn't handle all the medical bills. I had so much trouble that my mother said, "Come here to the U.S.," because Medicare didn't cover us in Puerto Rico.

Jessica: We got homeless because the landlord got mad at Mom, and she had to move. It was terrible. I have to take my medicine now. It's a big pill. I hate it!

Hector, Jessica, and Pablo Sanchez

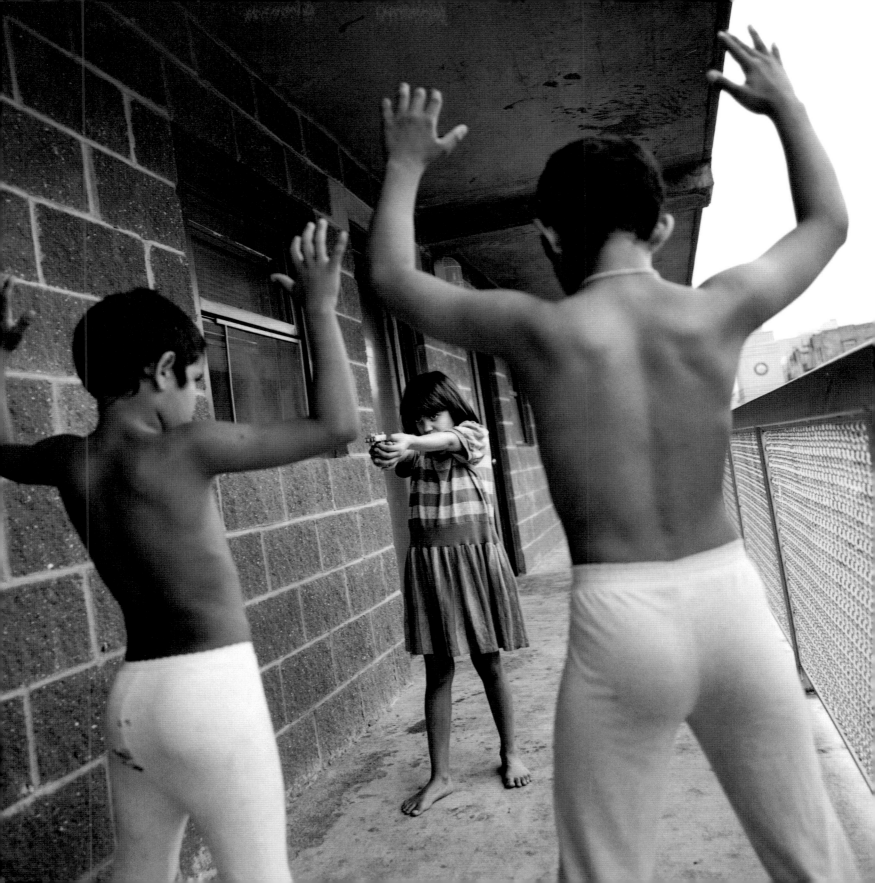

Teresita Ortiz

A Letter in a Poem

When I was out there
I really never told you this.
So read this letter carefully
You don't want to miss
A single word that I have written
So open your mind as I begin.

Writing letters to you
Expressing how I feel
Words pouring out my heart
Showing you I'm for real.

Telling you that I miss you
And that I love you so
Telling you the plain truth
So that our love will grow.

It will give you all the answers
to all your questions
So turn your frown upside down and
Forget about depression.

Kissing is a Habit

Kissing is a habit
Love is a game
Boys get the pleasure
Girls get the pain.
They say that they love you
We think that it is true
But once the belly start to grow
They say the hell with you.

Six minutes of pleasure
Nine months of pain
Three days in the hospital
and the baby still has no name.

Father's a bastard
Mother's a whore
None of this would've happened
If the rubber wouldn't have torn.

Jaime Molina and Teresita Ortiz

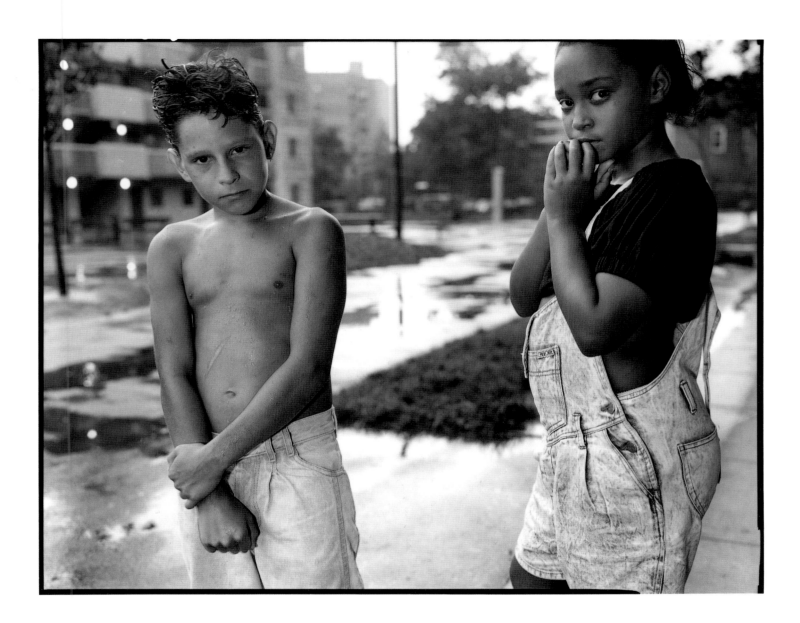

Carolyn Barberra

I didn't think I would ever be homeless. A lot of people think it's laziness, that the mother or father is lazy and that's why they're homeless. But there are cracks in life — and people fall in. I remember when I heard a story about a homeless man in Bayshore who was run over by a Toys 'R' Us truck. He was in a cardboard box, and they didn't know he was in there.

When my five kids were babies and I was on my own, people came into my path who were homeless. That was my first encounter with it. One was a professional model, all made-up, the whole nine yards — and she was homeless. She fell on hard times, got lost, because of the drug thing. She had this thing with her lipstick. She was constantly putting on lipstick, making sure it wasn't out of line. She couldn't see herself as looking good. I ran into her at Motor Vehicles. Her boyfriend had flushed her wallet down the toilet. She had no identification, no money. I'm Christian, she was a Christian, so I let her stay with me. But she had too many cosmetics, and they smelled, and after a while she left. I tried, at least, to help the homeless. I hope I did something for someone.

Believe it or not, I always wanted six children. I've got five. I wasn't married — Taadah! There are three different fathers, but we're okay with it. I guess my Catholic upbringing made me think about not using birth control. My daughter Amanda's father was one time that I thought about marrying. It's not that I wouldn't have married him. If he woulda' stayed stable, I would have. But before I had kids I was in drug culture, too.

I don't know what to say about homelessness. Just that we're not looking for greatness. We're looking for help.

Anthony Garrett and friend, Astoria Pool, Bronx

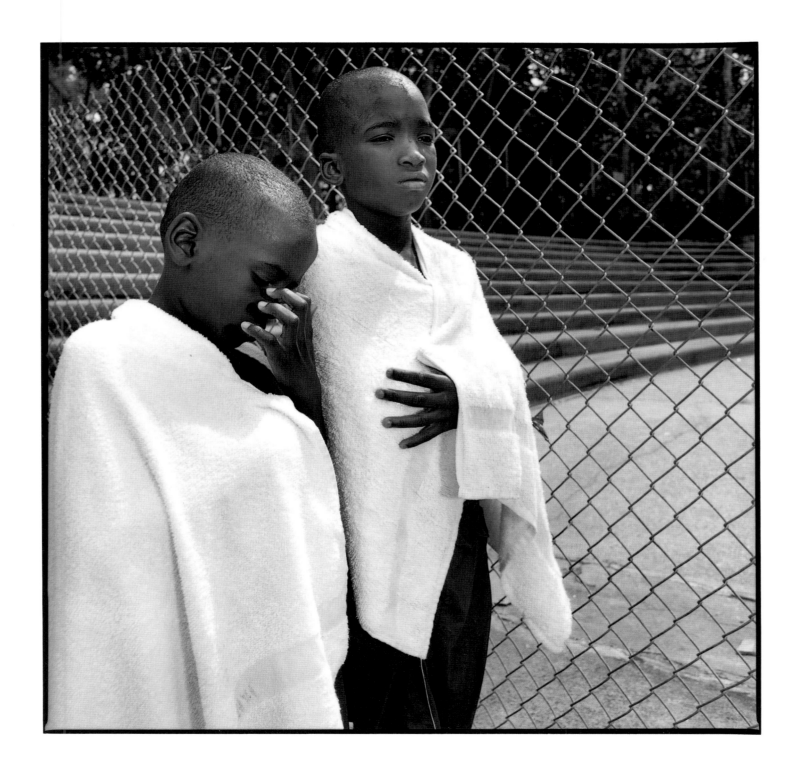

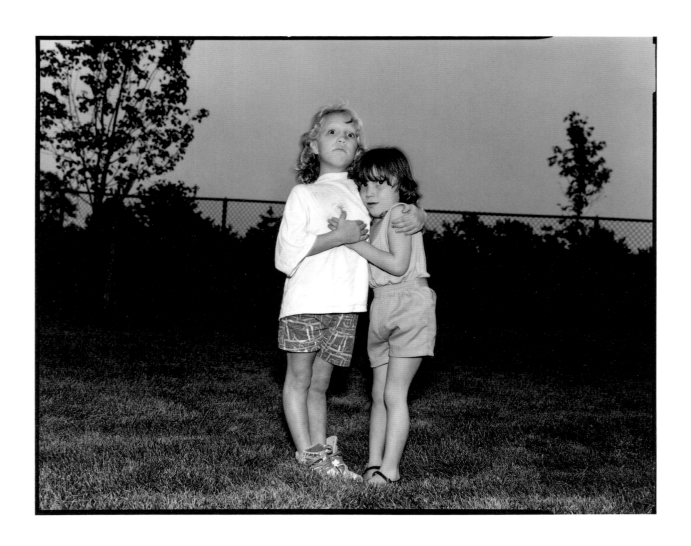

Annette and Pamela Worth

Keith Worth

Their mother dropped the girls off at my job one night and that was it. I'm not kidding.
I don't want my kids to be raised [by a woman] like that.

Crystal Webb

I had to leave my mother's apartment because of domestic violence. It started with my sister. She used drugs and my
mother took her in. It got worse and worse. She started stealing. She demanded money from me and when I wouldn't give
it to her she kicked me so hard I had to go to the hospital. (She's much larger than me. You should see the size of her!)
I was going to have an operation. My leg was in a cast for weeks. Both of us could not live there with my mother.
My sister went to rehab, but it didn't work.

My son Ross, who is four, has epilepsy and hemiplegia. He had a stroke when he was four months. Hemiplegia is only
known in Europe. It's so rare here that he made the medical journals. I tried to explain to my sister that arguments and
loud noise brought on an attack. I was there at my mother's a whole month and he had four attacks there.

My husband hasn't given me any help — and I want a divorce. We were together eleven years, and have been separated for
three years. Fourteen years. He is just plain mean. But I can do it on my own. I don't want to pursue him in court. I don't
even think about it. I can handle any problems he throws my way. It makes me stronger. I sent George, who is thirteen, to live
with him because of school. But he and his girlfriend treated George so badly that I'd never force George to go back. Never.

I was a home attendant. I had two jobs, but I had to quit because I had no time to be with my children. I try to work with the
kids as much as I can. I ask them what they want to do, and I take it from there. If one of them has an interest in basketball,
I'll get him in a school with a good athletic program. Whatever they choose to do. Justin is an honor student. He just finished
first grade. Parents are supposed to make their children as comfortable as possible. So I read to my children all the time.

If you have a goal in mind, then being homeless is nothing. We're not going to be homeless forever. We're only here 'til we find
better housing. If we make friends — all the better. It's a time to teach the children to share responsibilities. In my house,
chores are done every day. We all have something to do. I'm very proud that my children are well-mannered, that there's
no fighting. I teach them well. They don't look for trouble and neither do I. I'm very proud of myself and of my children.

Linda Rodriguez and Jaime Molina

Linda: Where I lived, the landlord wanted to sell the house. He wanted us to move out without no payment whatsoever. So when we refused he tricked us into going to a meeting, and while we was there, he evacuated our apartment and everything in it. We were warned, but we just didn't believe it. We thought if we stayed there — if we refused to move — there was no way he could sell the house. So we stayed there for about four months, sleeping on the floor. Then he evicted us. I have nowhere to live, but I would like to have my own apartment, to further my future, you know what I'm saying?

I had been working as a supervisor of the ADP Construction Company. I loved that. And I worked as a quality control inspector. That was in a factory. And also as a waitress. I was single for nine years and I had babysitting to pay, the rent, the telephone, the light, the gas. One time I worked two jobs, from 11 to 3 and from 5 to 12, in order to get my kitchen set and the kids' bunkbeds and things like that.

It's not that I want to be here. It's that we have no other choice. But you just hang on when it comes down to your children; that gives you the strength to hold on as much as you can. The people are friendly in this place. We all know we're going through the same situation so there's no reason for one to have to fight with the other, you understand, 'cause we're all in the same boat.

I have dreams for Jaime and Gina and Raymond. See, I never furthered my education. I had six months to graduate and my mother went to school and she removed me and the principal looked at her and said, "Listen, I don't think you should make that choice for her." And I never forgave my mother for it. She never gave me what you could call that second chance. Well, this is what my son wants now. He talks about going to college, wanting a home. The second chance I couldn't have, I'm giving it to him. The same thing with my daughter.

Jaime: When I think about the future, I think about going to college, because if I don't, then we're just going to live in the same old apartment. I want to buy a new apartment, bigger. I want to have four dogs in the backyard house, dogs that my mother likes: German Shepherds. Then I would like to have about two cars, one pink one for my mother, one for me, and if my brother can't buy one, I will buy one for him. If I have enough money, then I'll put some money in my bank account for my children and if I have children, in their college funds.

If I have a wife and if we buy our own house, I would like it if my mother would come in too, so we could all be the same family as ever. We would be just one happy family.

Francheska and Frances Sanchez

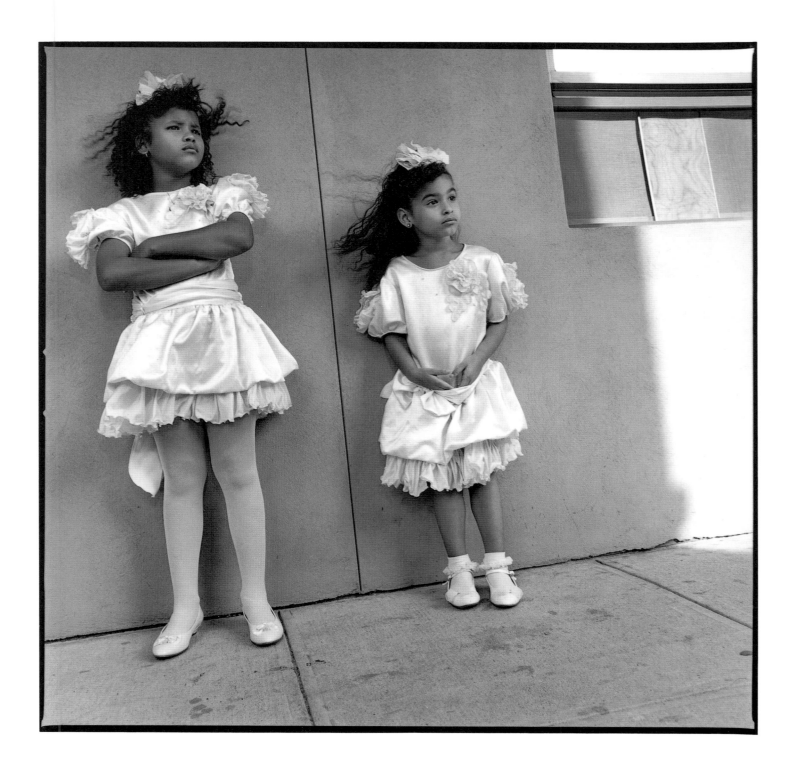

Raymond Rivera

It's not that hard being a single dad. It's as hard as it is being a single mom. Maybe with a dad, it's a little different. The kids respect you a little more. My kids have respect. They're good. They never have any trouble in the playground.

I lost my apartment because when I was unemployed. My wife ran away with a bus driver. We needed jobs to pay the rent. She was a cleaner in buildings, and I worked as a floor cleaner for seven dollars an hour. I gave her fourteen years of my life, and while I was unemployed, she left. I wanted to give the kids a home, but I couldn't pay the rent so I had to leave.

I don't plan to live like this. I didn't want welfare. I've been working since I was sixteen years old. What I hope for my children is something better than what I have. I dropped out of high school in the tenth grade. I don't want them to follow my steps. I want them to stay in school and finish.

Jose, Xavier, and Jocelyn Rivera

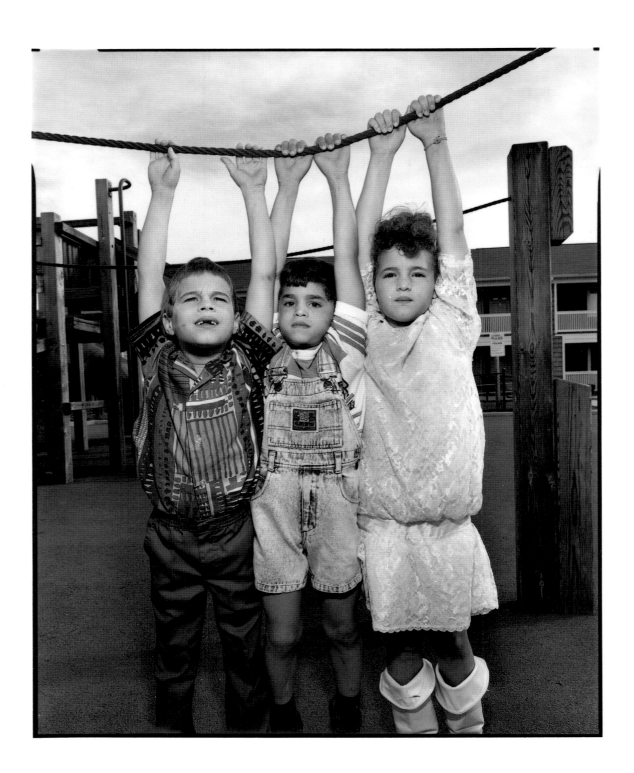

Tiffany Jackson

Q: Where were you living before you lived here?
A: Down south. Arkansas. We were living in a house, always a house, never an apartment.
What happened? Why did you have to leave?
There was no reason. We just didn't want to live there anymore.
Then you came to the Bronx?
Yeah, we lived in another shelter, Jackson. It's not a very nice place.
How is this place better?
'Cause it has a refrigerator, a stove, a bathroom, and a bigger, bigger, bigger refrigerator. We have a TV (well, you have to buy your own TV, though). We have a twenty-inch TV with a remote.
So what's your favorite subject in school?
English, spelling, and reading. I don't like math.
What would you like to do when you grow up?
I think I want to be an actress, then a dancer, then a singer, then a teacher.
Will you be leaving H.E.L.P. soon?
I'm leaving to move to Manhattan.
Are you excited?
Yeah, but not really because I'm going to leave all my friends and I'm going to have to go to a different school and they're going to make fun of me like the other school when I first started because I have big ears because my ears don't have a gristle.
Ah, you have great ears. Look, if you could have three wishes, what would they be?
I would wish to be an actress, a dancer, and to have magic.
What would you do if you had magic?
I'd make my teacher disappear into a cockroach — she's mean. And then I'd make the students that make fun of me into little insects and smash them. And then I'll grow up, and get my way all the time. If my father says I can't go outside, I'd stay there and make my spirit go outside and play. And everybody that died and wasn't supposed to die, I'd make them come back to life and everybody that did wrong and they knew they did wrong and they broke out of jail, I'd execute them.
Anything else?
A lot more things — but I can't think of them.

Krystal Santiago and Cynthia Maldonado

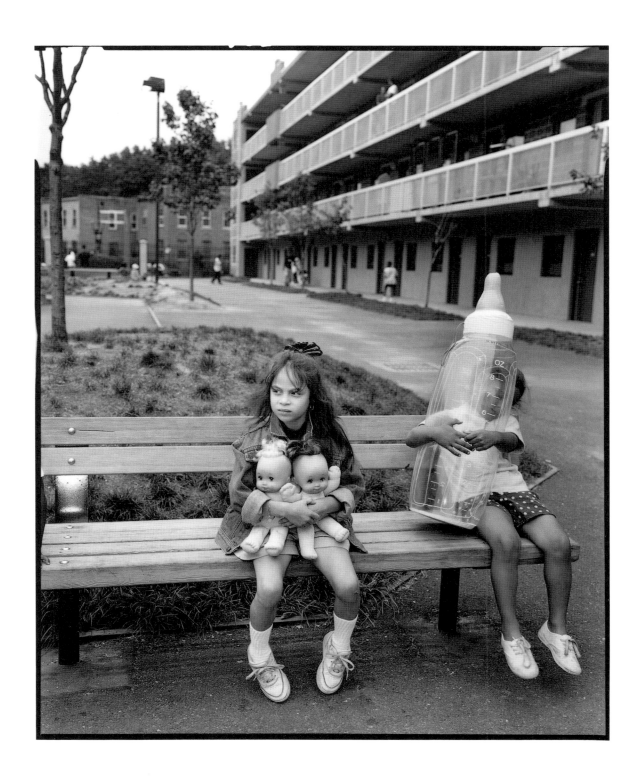

Albert Jenkins

I got custody of Andrea and Anthony two years ago. Since I got custody we never really had proper housing. We stayed in four different places. I was living in Atlanta at the time and had not been involved with their mother for a while. She was heavy into drugs. After she fell back deep into drugs, the kids were put into foster care, and they contacted me and asked me, "Did I want them?" I very much wanted them, but they gave me the kids sooner than expected and I wasn't ready for them — I had nowhere to go. When I first got them I didn't get a chance to get proper housing. The first place we stayed was down in Georgia, at my brother's and mother's, and then with my aunt for a while. I was working, but that wasn't any good because my aunt was abusing the kids. Then we moved back to New York (where I've lived mostly, since I was young) and stayed with my cousin for a few months. I'm trained as a chef, but I'd been out of work about two years. The main reason is no babysitter. Once I get settled down in a new apartment and have a proper babysitter, then I can go back to work. It's almost impossible for people with kids to work. You just can't leave the kids alone.

I thought the kids should go back into foster care while I found a place to live, but the lady at C.W.A. [Child Welfare Administration] was nice and said, "We're here to keep families together," and she placed me in a day! She writes to me once a month, and I call her to let her know how we are. When I first came here four months ago with my two kids, I was expecting some dinky, dirty hotel room, but this is great. I appreciate it very much. The kids love it here, and they have their little friends here. It's better than where I was staying before I came here. It's the first time that we've really been all by ourselves. Of course it'll be better once we get our own place. If you respect people, they'll respect you. It's how you deal with people. Everything is going my way. I made more progress here in two months than I have in two years.

Andrea and Anthony Garrett

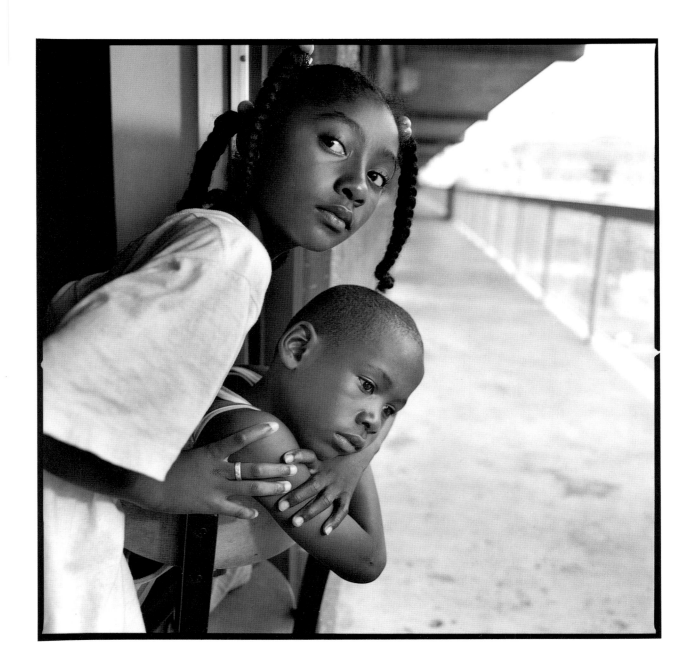

Alicia Jackson

I've got three girls (named Precious; Kwanasia; and Kenya), and three boys, called Kreem; Kelvin; and Keith.
But I didn't want girls; I wanted a basketball team. When I couldn't afford the rent I had to go to social services.
I didn't want the kids in a motel situation, so they recommended this place instead. But three months is a long time for
emergency housing. People get really frustrated here. When you first get here it's all right. Three months, and the place
starts getting to you — like you're doing time.

My mother helped me when I had the three boys. Then she stopped — I guess she figured that was enough.
I always had their father, but he passed on when I was pregnant with Precious.

It's no problem having six kids. We get along. I have a bunch of clowns. I try to teach them manners. Sometimes,
we stay in the apartment. Saturday is like our day. We do things together. We go the supermarket. We have fun with
ourselves. Kids are people, too. They tell me stuff. We have adults who are not perfect, neither. It's not always
'cause you're little people that it's your fault. You can express your feelings. It doesn't have to be in a nasty, sarcastic way.

I'm directing them towards whatever they want. Kreem, for example, is going to be a basketball player
(but if you ask me, they all could be comedians). Kelvin is in trade school for computers at Central Islip. He likes that.
Kenya wants to be an actress. I'm getting my G.E.D. [General Equivalency Diploma] now.
I believe that life is up to you as an individual — I think my kids understand that now.

Kenya and Precious Jackson

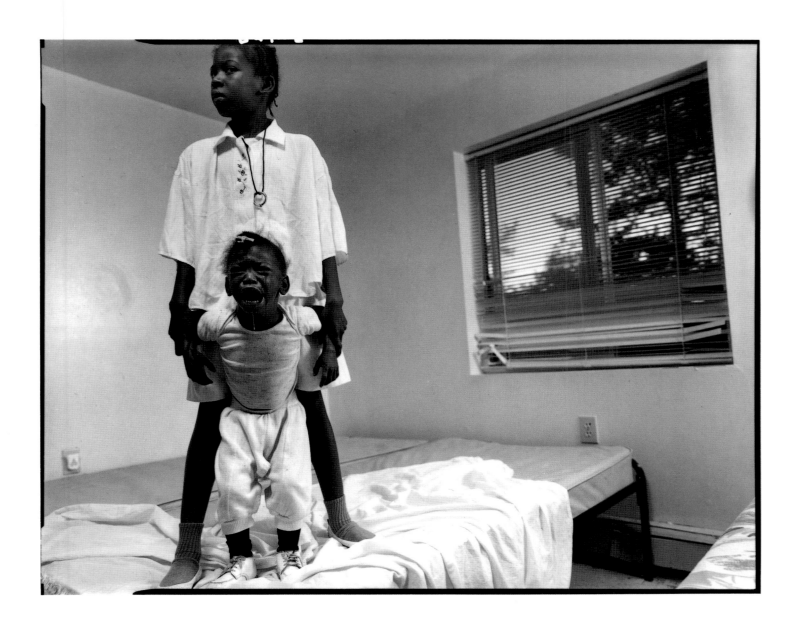

Kathy Holland

The relationship went well for the first few months. But he had had a cocaine addiction as a young adult and supposedly went through rehab. Basically he fell off the wagon. From there, he started doing crack, and the emotional changes and the verbal abuse got.... I thought I could help him but it doesn't work out that way.

It's like a fight between good and the evil with drugs. And I think this is basically why I stayed as long as I did. I saw him not want to be this way. He wanted help. He wanted to be normal. And I thought I could help him, but to my own detriment. Basically he made me lose everything, and I almost lost my kids because of him. My dad came out and rescued us because the law got involved when he got into drugs in a big way and almost killed me on a couple of occasions. Choked me to the point where I passed out and he just left me on the floor. And he would say, "I did that because you wouldn't shut up."

The worst thing in the world is watching your children, who are polite kids, great kids, the kind of kids you want around to play with, become displaced, angry. They feel abandoned, deserted. Their lives have been turned upside down. God forbid something should happen to me — they'd be destroyed. That's why I had to pick my rear end up and do it for my children. That's what's holding me together. But it's hard. And somebody should tell the politicians that if the welfare cuts happen, there's going to be children dying. Suicides and abuse are going to skyrocket, because we're already spread so thin.

If you get involved with someone who relapses on drugs, get out — because you'll wind up losing everything. That's the bottom line. Because once a junkie, always a junkie. They smell money. You can hide it in the best place possible and you know they'll find it because of the addiction. It's devastating. He was beating me once and he screamed at me: "Put down the baby, why was I holding the baby?" I was doing it for protection — but it didn't help. He hit me while I was holding an infant — his own daughter.

My ex got food stamps before I did — because he was a junkie. He got all the help he needed because he had a physical addiction. But you can't see my scars, and you can't see my children's scars — but they're there, alright.

Jazmen and Michelle Fournier

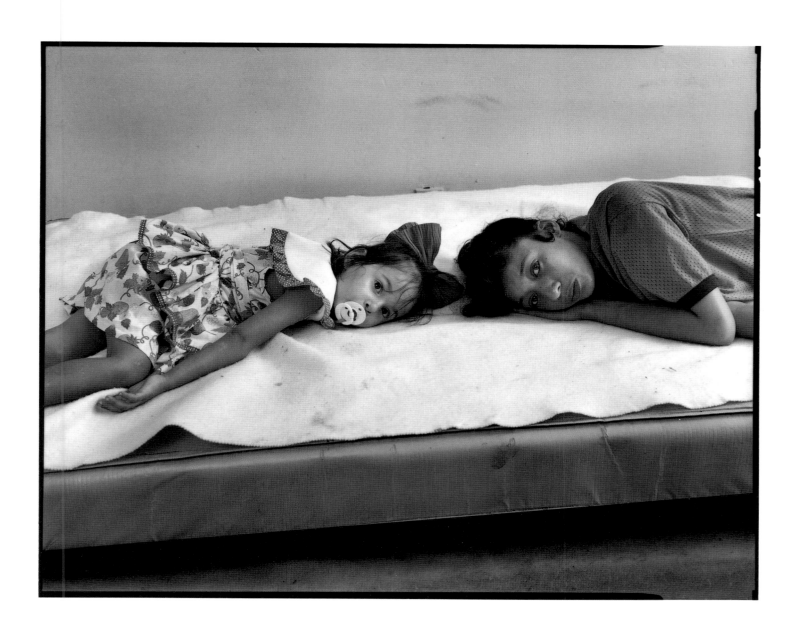

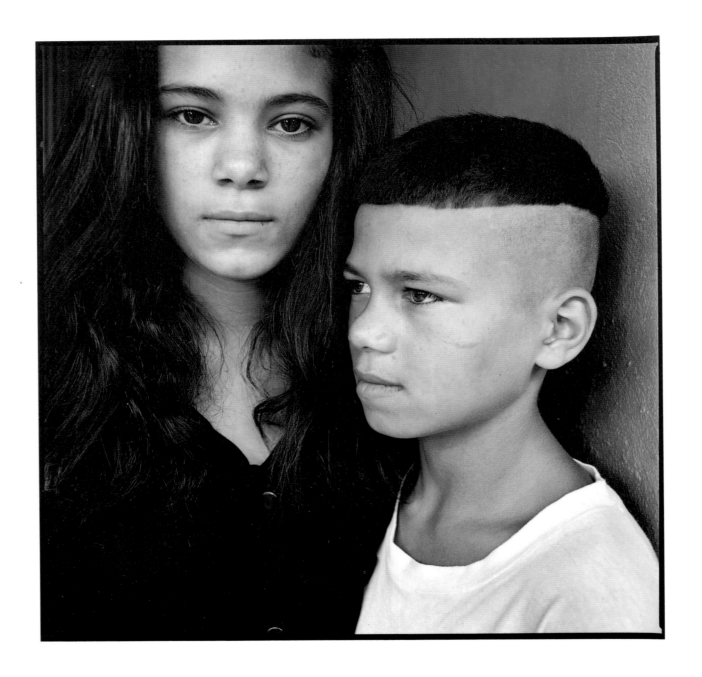

Amy and Anthony James Penny

Anthony James Penny and Amy Penny

Anthony: Our house burnt down — that's how we got here. I like Brooklyn. I have family over there and I have lots of friends and there's nice people that I know on 17th Street and it's nice, it's quiet. There's no danger around here, no drug dealers or nothing like that. I would really like to stay here until Christmas Day and then move to Brooklyn.

I am thirteen years old. When I grow I want to be a cop because I like to get bad people off the streets so everybody could live a good life. Lately I've been fairly sad because I always think about when my father died. He passed away thirteen years ago when I was eleven months old. I've seen pictures of him so that's the only way I know him. My aunt was going to take us to the funeral to see him but she never took us. He got shot right in the heart with a rifle. My father's sister's boyfriend shot my father. The whole thing was about an argument 'cause of the building my uncle owned. Well, he's not my uncle no more; I don't like him. His sister hit him, so my father hit her back and then my uncle he went to the back of the room, and got a gun and he shot my father in the heart. My family is prejudiced of my mother because she's Puerto Rican, and they're, you know, white and Irish. I got a prejudiced family.

It's starting to get better here. People are getting nicer because some of the bad people moved out. There was bad kids in here. We used to be at a free shelter. There were rats in it and there were mice and lots of cockroaches and the people were mean and the guards were mean. And in the basement there were dead people still from where the hospital used to be. I seen coffins in the basement.

I go to school every day. Wait till I go to high school — I'm going to get an education and I'm going to get a job and I'm going to get a car and I'm going to support my family. If I had three wishes I would wish for a thousand wishes: money, my own police station, and, oh yeah, I'd wish for a car.

Amy: In the shelters, it's nasty and dirty. You have to use the same bathroom with everybody. And the men go into the girls bathroom there. I couldn't even take a bath by myself because my mom had to be there, on guard. Here it's a big difference because you have your own bathroom, your own kitchen, your own room. It's real pretty out here. My brother loves it because there's a park out there, and he's always out all the time. The only thing is my mom has a problem with the rules. When she goes out, she sometimes don't make the curfew, but she says that it's worth it, because from here we can go to our house.

Gregory Newman

There would be no homelessness if there were more programs like this. It helps people. They give you a set of pots and dishes. They start you off. They get you on your feet. I think that's very good. You have your own space. They have schooling and day care. They take people out on trips. They even took us to a Mets game.

My kids feel fine here. You know, they're very polite, my kids, but in Spanish. They talk a lotta Spanish.

Milagros and Moochie Rivera

Milagros: I lost my apartment because my landlord wouldn't fix anything. He wouldn't fix the pipes: there were huge water bugs coming out of there all the time. There was so much rainwater in the wall, that the whole wall was falling over and peeling. It was too dangerous for my kids. I had to leave and welfare didn't pay enough for rent somewhere else. I couldn't go to my mother because my sister is there with her two kids. Here, you don't have to worry, but there are some problems. My kids got lice from I-don't-know-where, and there are rats at night in the playground — they come out and have a party. My friend's newborn was bit by a mouse and the mouse turned out to have rabies. I keep my apartment real clean. I mop my floor four times a day.

Moochie: I love Mickey Mouse, Barney, and Big Bird! I like playgrounds, corn, broccoli, and macaroni.

George White

The worst thing about city shelters is that the staff are all alcoholics. They get drunk, and then they harass you.

Stephaine Fournier and Nelson Newman

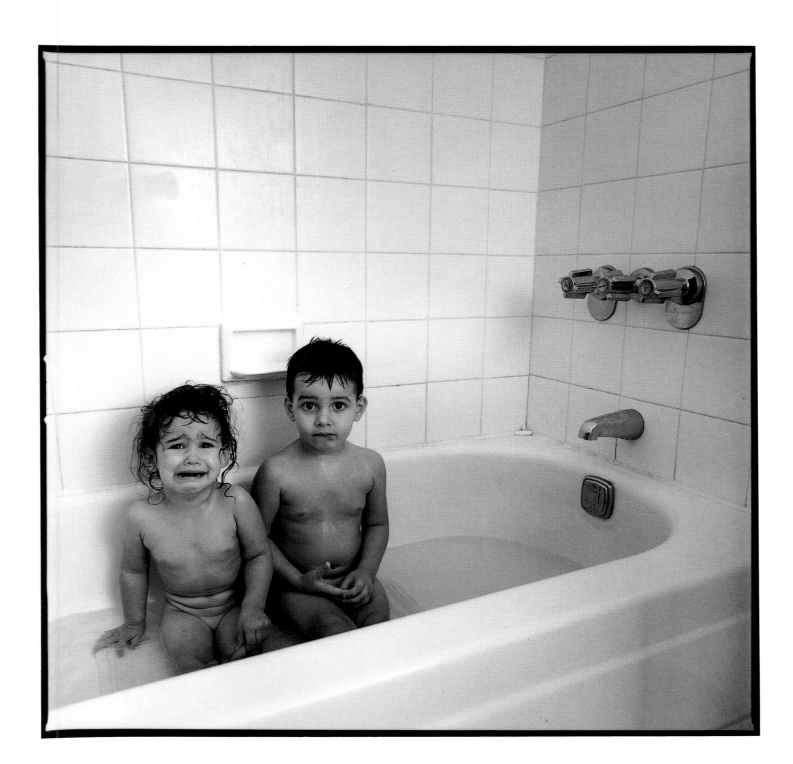

Marlene Perez

Before I was in the shelter I was in my grandmother's house for five months. Before that we had our own home, but it got burned. So that's when we had to go to the E.A.U. [Emergency Assistance Unit]. They sent us first to Jamaica, Queens, and from there they sent us over here.

But it wasn't hard for me to move out of the house I was living 'cause there was a lot of drugs there: I didn't like that. So it's good that my house got burned. I say it's good.

Now, there's a lot of people who say, "Why you living there?" Surprised, like, "You're not feeling bad, cause you're living there?" I say I feel that way sometimes — because I'm homeless and all that — but it doesn't matter now. The only thing that matters is that we got through it and now we're going to get our new house.

'Course, I think about what life might be like five years from now and I know it's going to be hard, hard, hard. Because it's not going to be the same thing like it used to be. My bosom's going to be growing. I'm going to grow. My mother's going to get old. And me? I'd better stay like this, fifteen years old. I don't want to be sixteen. Now I feel like I'm still a little girl, and I feel like staying that way forever. It's not fair that you have to grow always. But life, it's like that.

I'm going to seventh grade right now. I'll go to LaGuardia High School. If not there, I don't know where: Cole or Brandeis in Manhattan. My favorite subjects are math and social studies. I like to play volleyball and baseball.

I want to be a model. I'm going to finish my modeling classes. I'm going to graduate this year, to be a professional model. They show you a lot of nice stuff there. They show you how to move, how to walk, how to paint yourself like you're going to dinner, how you have to dress, all that. All that kind of stuff. That's what I like. Sometimes it gets you tired because you have to be always standing up, but mostly it's nice, especially how to walk straight. There's different levels. I'm in level seven; that's for the fifteen-year olds. They say level seven is too easy for me. I don't know; I find it a little bit hard, but it's nice. In level eight I heard you have to be walking with high heels and I can't — that hurts a lot!

Bianca and Margie "Cookie" Cross

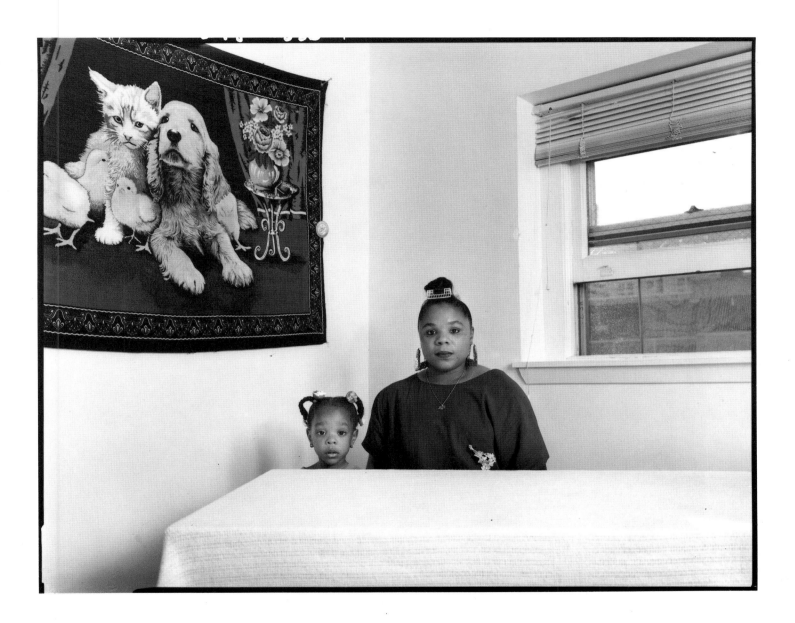

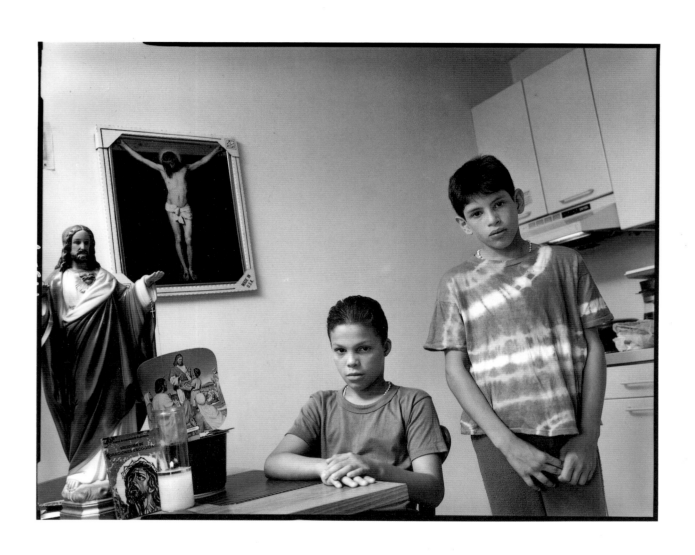

Jonathan and Noel Cruz

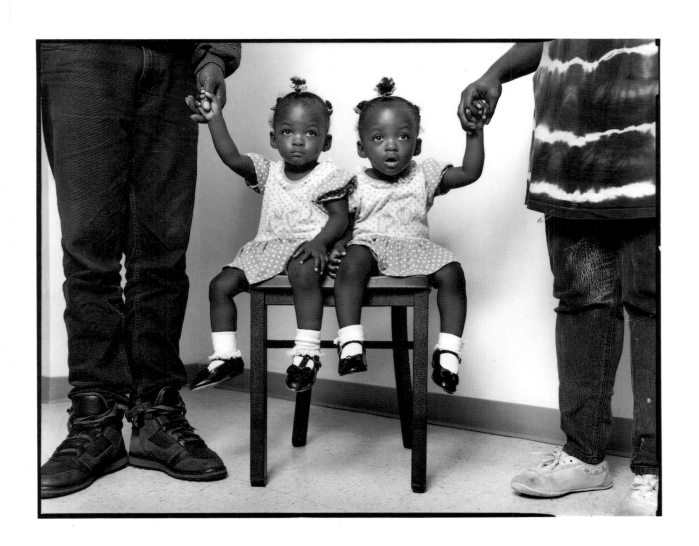

Vashira and Tashira Hargrove

Nellie Torres

Bianca and Yasmine have the same father, but he's gone. I'm raising them alone. Of course it's a hard job. I get aggravated and feel like hitting Bianca, but I don't — I just yell at her.

I got in a big fight with a cop who saw me on the street during the day. He said, "You have to be in school. You're only thirteen." He wouldn't believe me, but hey — I work Monday to Friday.

I always clean good every day. I do cabinets and the refrigerator every Saturday.

Angela Rivera

I always wanted to live in New York. I lived in Philadelphia for about eight years. I came to New York but had never thought about being homeless before. But I didn't have no choice. People don't realize how hard it is for the homeless. There are days I cry at night. But I want something different for my kids. (I have three — Mark, Joanna and Angela. Their last name is Bracero, after their father.) I want a private house, something suburban. I want them to have fun, to go to school, to get good jobs. I want them to be educated and respectable and not have kids too young.

My mother had her first child at eighteen. I wish she woulda' had more support. I was in and out of foster care. At eight I ran away from my foster home. I bought a train ticket in upstate New York and ran away to New York City. I took a subway to my mother's — that gave her a big surprise. I ended up going back to foster care because there were too many problems with my Mom and Dad — health problems. It wasn't a good environment. Look, in my life I've definitely had my ups and downs. There's nothing I can't survive. Friends have said, "You could write a novel — it would sell out."

Nellie Torres, Yasmine Nieves, and Bianca Nunez

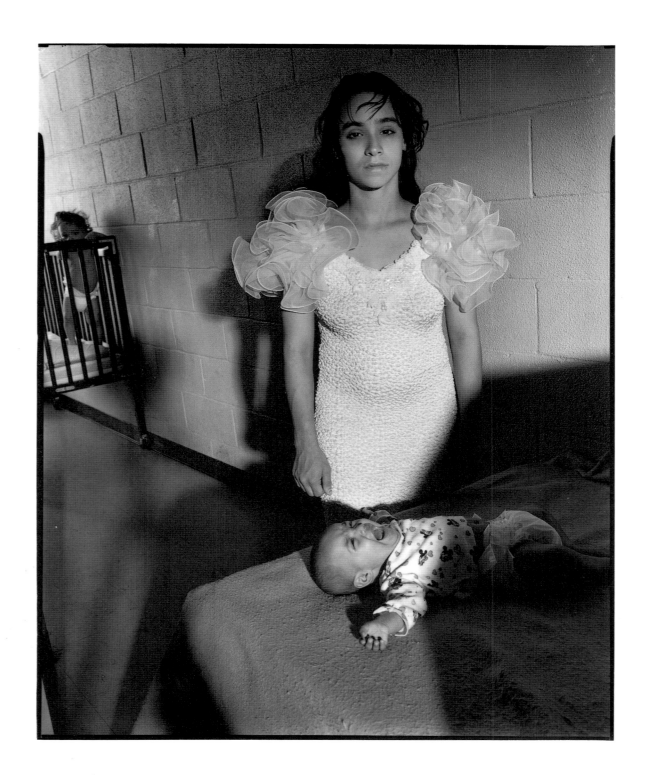

Evelyn Ruiz

I was living in an abandoned building. There were empty rooms where we used to live and people would go in
and sell crack there. It wasn't too bad, though, because there were people watching for us. Across the street there were
people that were kind to my mother — they would watch that no crack people would go into our house. But it was not a
great place to live, so we moved out and we went to our grandmother's house. My grandmother lives on the seventh floor
and mother is scared of elevators, 'cause when she was young, she got stuck in one. So she can't be going up and down
those steps every time. After a while, she just couldn't do it no more,
so we moved to the shelter.

Elige McGee, Jr., daughter Nylicia McGee, and son Ronald Booker

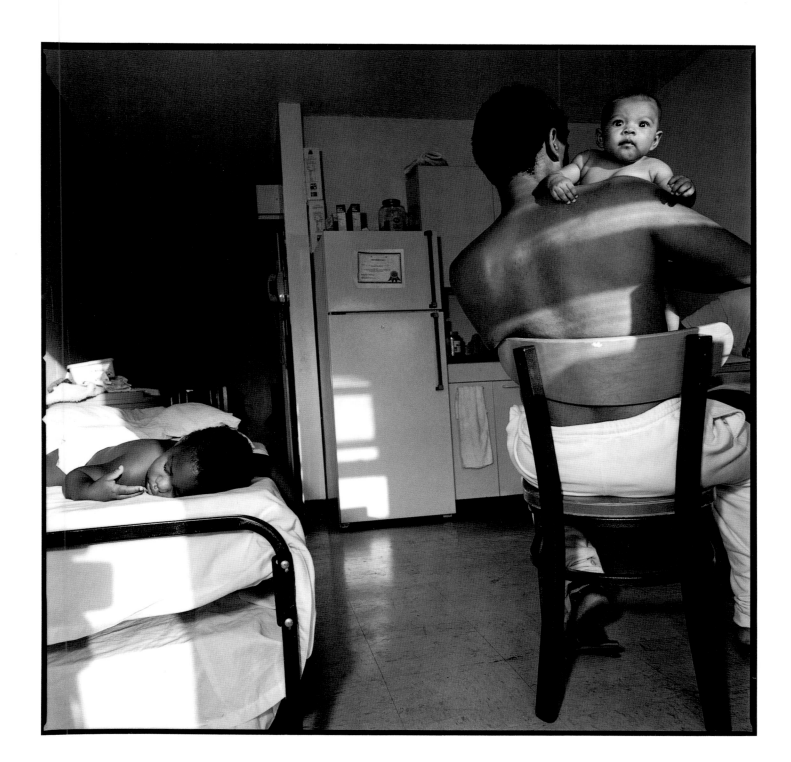

Elizabeth Penny

In the shelters there were so many people. I felt uncomfortable because it didn't feel like a home. Over here it feels like a home — I'm in my own apartment and I can do my own cooking.

I lost my apartment when the landlord lost the building and the people that took over raised the rent. I couldn't afford it. So my rent started backing up where I couldn't catch up with it. The welfare didn't want to help because I received a widow's pension from the kids' father that was killed thirteen years ago. Then I met Victor Bruez and he started helping me financially with the kids. Matter of fact, he helped me raise the children.

But me and my children need a home. I don't want to keep being homeless and be in transit from one place to another. It's not a good thing being homeless. It's sad and it's hard. On Christmas and Thanksgiving, especially, it's been very hard for us. And I'll tell you one thing I know from this: if there's anything people could do from stopping to become homeless, they should.

Elizabeth and Amy Penny

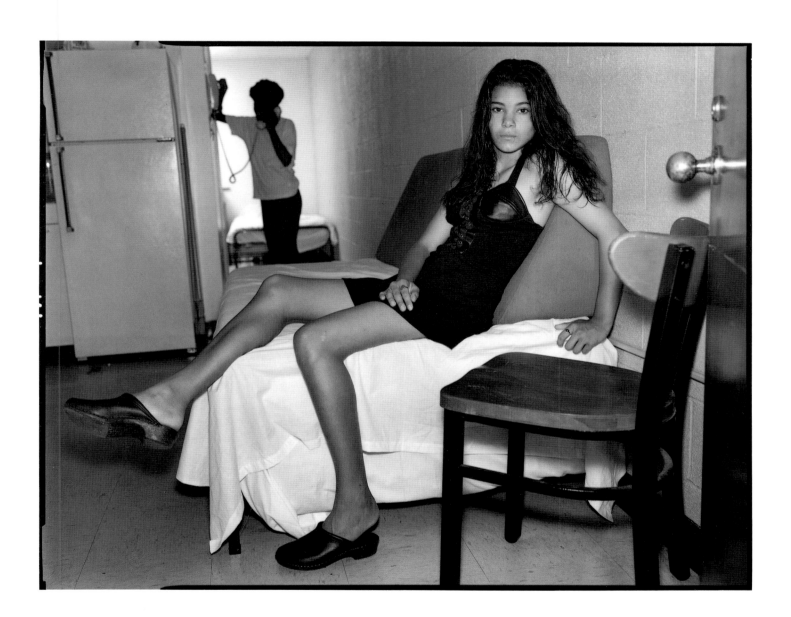

Nilsa Ruiz and Evelyn Ruiz

Nilsa: When my daughter Evelyn was two years old, she could talk her heart out. Now she's quieter — maybe being home-less had something to do with it. It unsettles a child. But this is a good place. I got my kitchen. As long as it's clean, to me it's all right. I would gladly get off welfare. I want to work. I've been dying to get off it. But I don't have any experience. I'm raising three kids. I'm doing it all on my own.

Evelyn: I like purple 'cause sometimes it's bright and sometimes it's dark.

Karen Rocha

He hit me and my children, and I was put in the hospital. I have stitches in my head from where he stabbed me. After I got out, I did go back to him. At that time I had nowhere to go. I had no money or anything. And I had two children. Then he did it again after that. He tied me up once with the cord to the vacuum cleaner. I was tied up for two or three hours until one of my friends came over. He ripped my hair out of my head, he punched me in the face. I was bleeding. My girlfriend sat me down and told me to get out, so I packed up and went to live with her. Honestly, before I met this guy my whole life was fine.

Carla and Jake Aragona

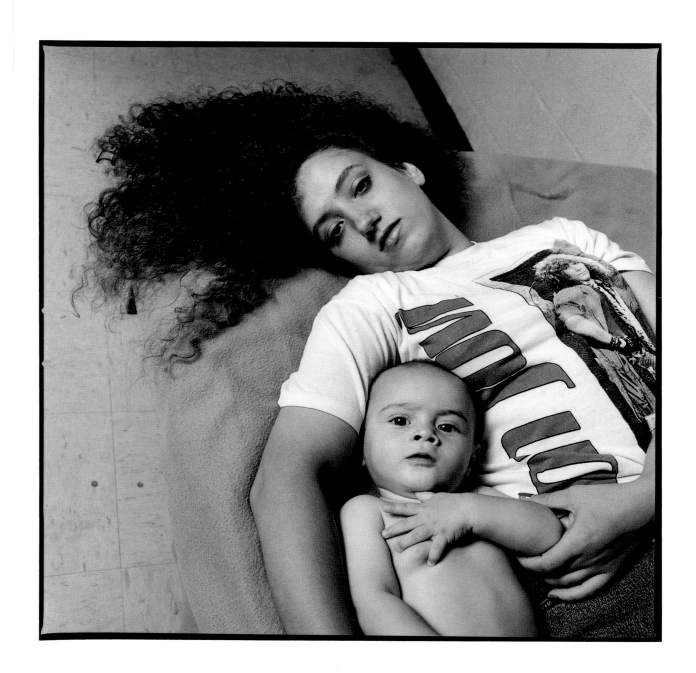

Yolanda Danielle Rhyne

Little kids is raised up like their parents. They're gonna have problems if their parents have problems. My mother didn't raise me right. She didn't tell me nothing about birth control. All she said was: "Stay away from boys." I didn't know what she meant by it. Then I didn't tell her I was pregnant. I was too scared. I waited until I was six months. I thought she might beat me up. My mother's got bad problems. She's messed up. Yeah, on drugs.

I didn't know about abortions. When I found out, I wanted one but they said it was too late. I didn't know I had options. I even wanted to have my tubes tied, but the doctor said I was too young, that I had to wait until I was twenty-eight, 'cause I might change my mind. If I hadn't had the mother I did, I wouldn't have any kids. I'm gonna tell my son, I tell you that, to use condoms and everything.

Irene Ayala and Enrique Andaverde

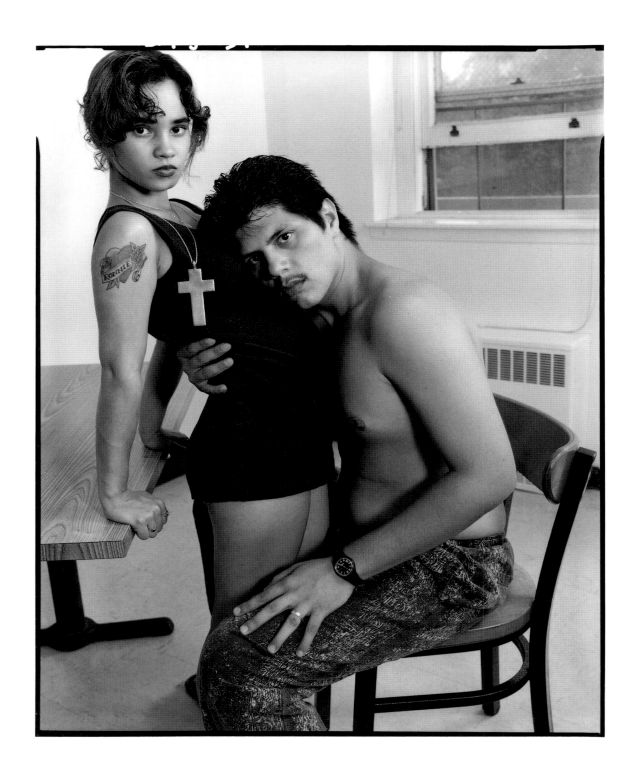

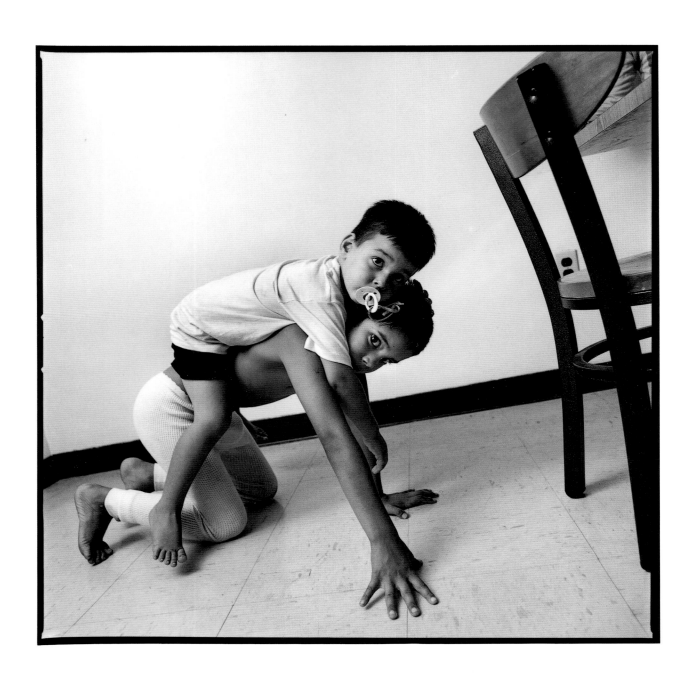

Nelson Newman (top) and Hector Sanchez

Milagros Vega

This is my first time in a homeless situation. We were in a situation at the time where we didn't have to eat or anything because I lost my job. And from what I've experienced, or seen on TV, homelessness is a nightmare. But this is really great. We have everything we need here: day care, medical, playgrounds, recreation, after-school programs, and workshops. They even help you, if you don't have your children, to get them back. I guess there are some people who just like being homeless. Or just can't handle it, as far as keeping an apartment. I know some people would just like to stay homeless. I know there are people like that — without desire. They don't want that responsibility. But I was not raised like that.

I have dreams for my kids. My daughter wants to be a lawyer. My son wants to be a chef, and my little one, he's going to be a football star. Me, I was a legal secretary but now I want to go into food nutrition. Legal work is a great-paying job but I think I want something a little bit more peaceful. I like to be walking around. I even prefer to do housekeeping in a hospital because I can move around freely. And to talk to people. In an office, I just couldn't take the pressure anymore. Especially when I worked for attorneys. So now, at my church, Las Gospel San Lupo, I work with the needy. We have a soup kitchen, we have care services, and a lot of other ministries. The soup kitchen serves over 600 a day. It's beautiful, and I like it.

People can tell the difference between my children (because they're more quiet, more peaceful) and the children that are used to being in the street, who are so rowdy in their form of being. You can tell the way the parents treat them — there's a big difference. I think it just makes such an impact when you think about children. My son was so wild at one point, but now he works in the church and he can even notice the difference. Little Brian helps to give out donations. It's great, really great. He helps out. My kids all work after school. They work and that helps. And that's an impact in their lives. Because how to get along with other people is the most important lesson. I see people here all the time fighting against each other, and we're all in the same boat, regardless what the problem was, how we got here. We're all looking for housing, looking to go out there and get something better, to get along better, to be kinder to each other instead of being so nasty. Nastiness happens a lot. It happens all the time. I've seen people that have come in and abused little children. It's sad to see that, there's no need for that. Children should play with children, adults should not get involved. But it happens. But we're living in this world, what can we do?

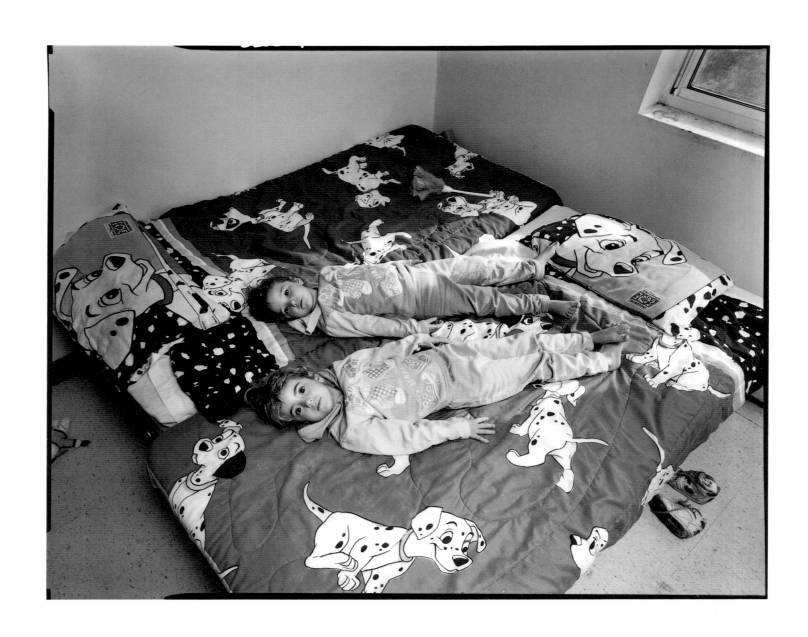

Cortney (top) and Amanda Joyce

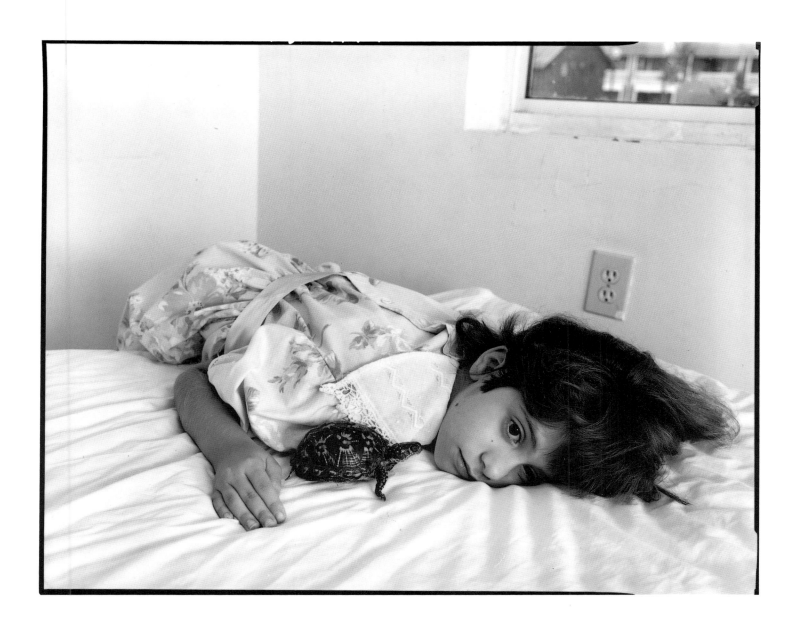

Amanda Barberra

Jacqueline Vaughan

I didn't want Brooke to grow up so fast.
I want her to enjoy being a child, and when it's time for her to be a woman, she will be.

Brooke Vaughan

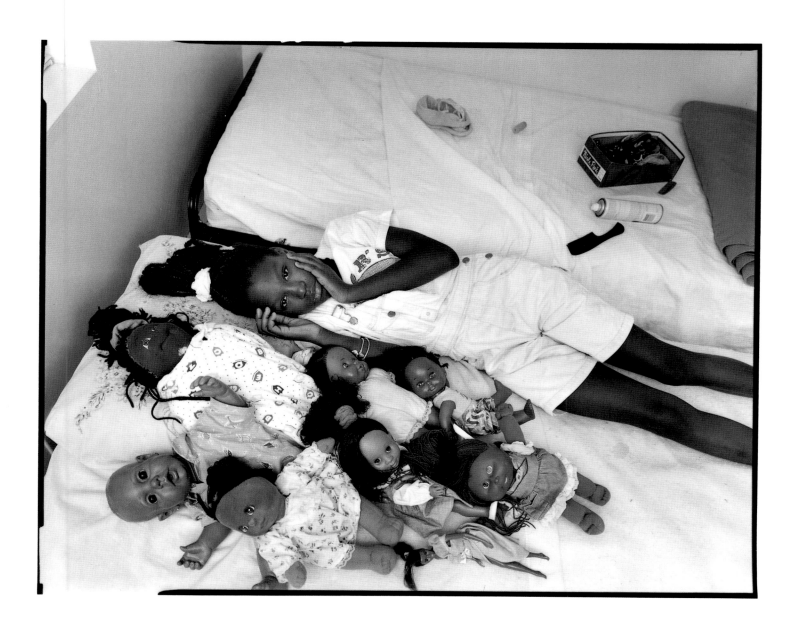

Dorothy Owens

I was forced out of my home. I really didn't want to leave, but when I broke up with my ex-lover, he became very, very angry. He became more and more in a rage, and his violence and emotion scared me. If I told the truth about the obsessive, it would be some Amy-Fisher-type shit! He robbed my dignity at nineteen years old. He was thirty-two. He stole my emotional heart. I was so young, it was like a hook in my mind.

You know the Wizard of Oz? Well, I'm that Dorothy. I jumped out of the witches pot, into the brew! Every man I've ever met wanted to own me against my will. There is no protection for women. My husband (we're separated but still friends) said I should leave the state.[Dorothy had married the father of her children, but the ex-lover came back into her life.] I told the housing program, but they wouldn't move me. They said I had to move on my own.

Remember the judge in New York, Judge Wachler, with the obsession and horrible harassment of that woman?
It was like that, and I couldn't take it any longer. Right now, I can get my sleep. Before, I was so paranoid that everything in the world would defeat me. My ex-lover went to my girls' school to try to pick them up one day. He had a drug history and that scared the devil out of me. I had to watch my back. My personal life interrupted my business life. So many interruptions can make you lose employment. If I had bucks like that woman with Judge Wachler, I could have just left town. I decided: "I'm not taking this no more, and if I'm gonna have to go to the housing people to get on track, then that's what I have to do."

I feel that I'm free here, but who ever knows? I'm smiling, but I'm still under stress. This is helping me heal.
Still, I'm lucky to be on this grass.

Rafael Cruz and Maritza Diaz

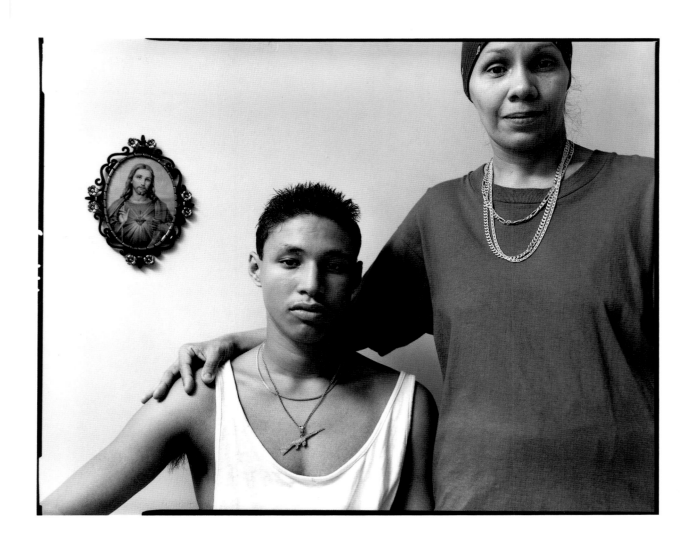

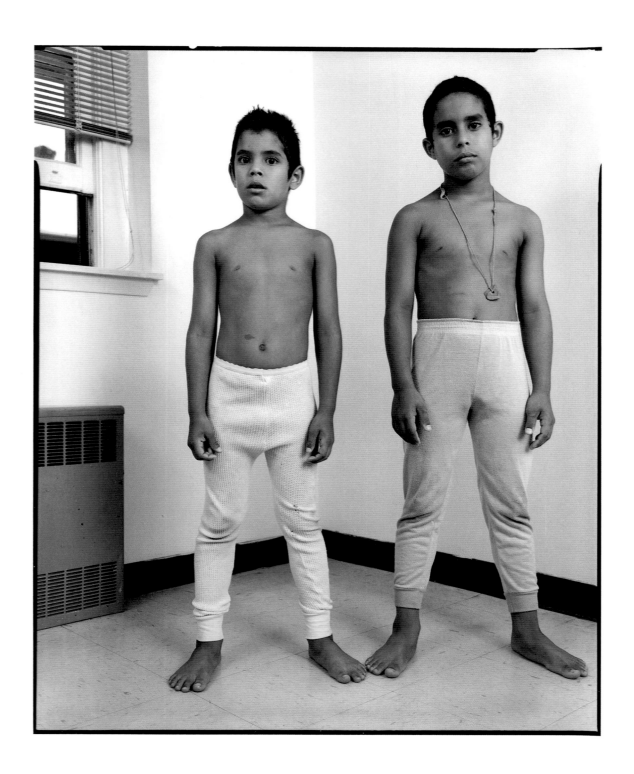

Maritza Diaz

"Don't cry," they told me. "We are crying because the landlord is throwing me out to America from Puerto Rico," I said to them. I had a lot of problems with my children then. They got asthma when they came, because of the change of climate and everything. Then they told me, "Don't cry." They don't know nothing.

But here, nobody can throw you out. Here you have own apartment. I never have a problem here. This is like a family. Black, yellow, white, we're all mommies. We are brothers, the same thing, the same blood. And soon, I'm going to have my own apartment. If God says so. I am the father and the mother in my family. My children have only me.

Hector and Pablo Sanchez

Victor Mateo

They should tell the people more about what's going on in these shelters. Some are something awful. We heard a guy killed his daughter last month in one of them. This place is different, quieter. H.E.L.P. is helping. You can get on with things. I wanna be a business man — for money. I like repainting stuff. I like working with radios and audios and all that. I studied in the Bronx how to record music.

Veronica Caravelli

I've been in emergency housing for two years now to get away from my husband, who had abused me and my daughter. I had him come over and help me out with the other kids so that I could take my daughter to the doctors and they said she was abused. She was four at the time. So I just left him.

When my son was eighteen months old, I was in an emergency shelter and my husband was in jail for harassing me. I called him up in jail and he said he was going to kill me. Soon he got out and came to get us. He said: "You see what happens when you put me out the house. This is what happens." Then he climbed into the kitchen sink on Easter morning, and he turned the hot water on and drowned my baby son. That was my husband's first child. That was his only family 'cause he was adopted. That was his real blood and he killed him. He's still killing us.

The abuse began two months after we got married. He started on my son. He gave him a black eye and then after that it calmed down. But then he wanted me to do things for him, and that's when he became abusive. He would slap me around for a while and push me around if I tried to leave to get out of the situation. The final straw for me was in August. I was in a shelter. We got into an argument and I wanted to get away. I didn't want to be there with the kids, so we tried to leave. He wouldn't let us out the front door. He pushed me up against the wall; he gave me a black eye and then I finally ran out of the house myself to a neighbor's house and called the pastor.

I thought that I had such a great family life that I could give it to him and he wouldn't feel any pain anymore. But it backfired and he showed me his pain.

Yaritza Mateo

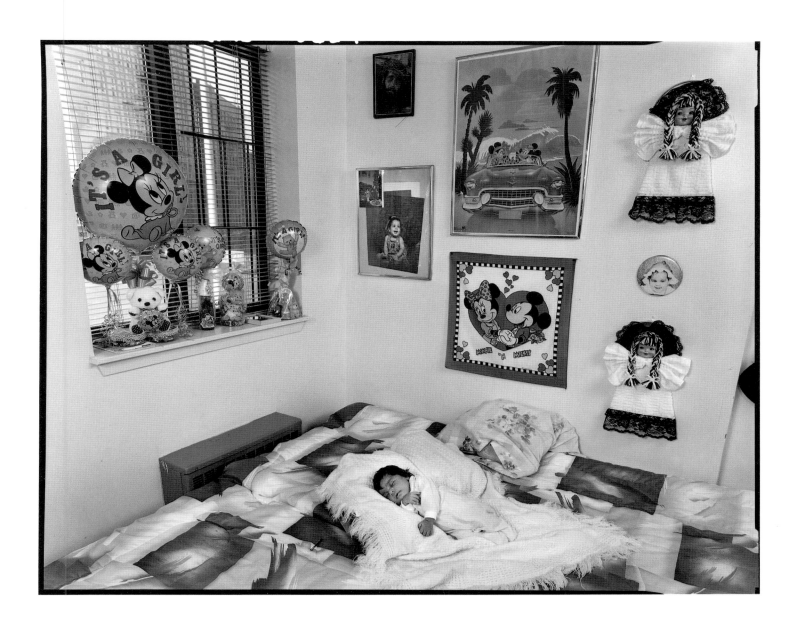

Natalie and Erika Escobar Ahay

Natalie: Today, we're going shopping. You know why I love this house? Because there's a playground in there. I play with my dolls, and I put them on my bed. We paint, and there's a kitchen. There's a lotta things here. I play with Jenny (my cousin). I'm gonna' be a doctor to help have babies. When I finish being a doctor, I gonna' be an architect and I gonna' clean TV's, and when I finish that I gonna' be — oh, I know, a doctor. But right now I want a big doll for me. My mom's gonna' make a dress and a shirt for my birthday dollie. I'll put on a hat. I love this dollie because the eyes — they're cute!

Erika: I want to be a policewoman.

Natalie and Erika Escobar Ahay

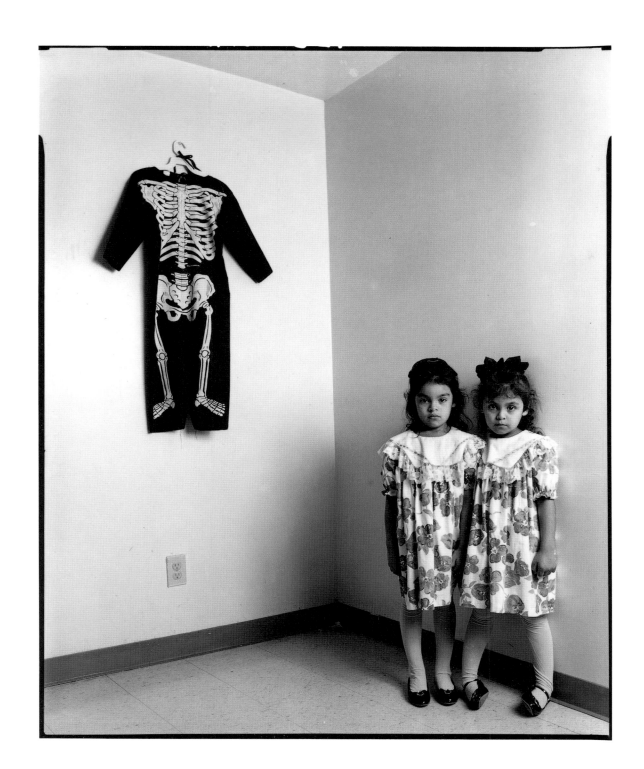

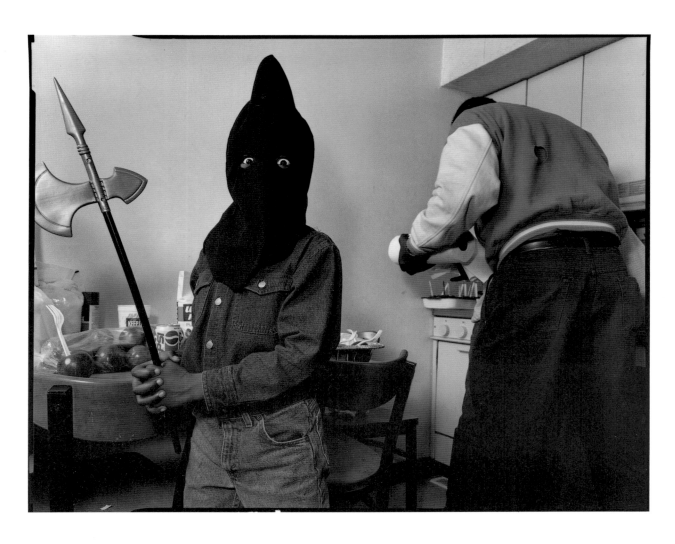

Edward Simmons

I've never seen anyone with an executioner's costume. We picked it out.
I'm glad Halloween only comes once a year.

Edward Simmons and son Edward

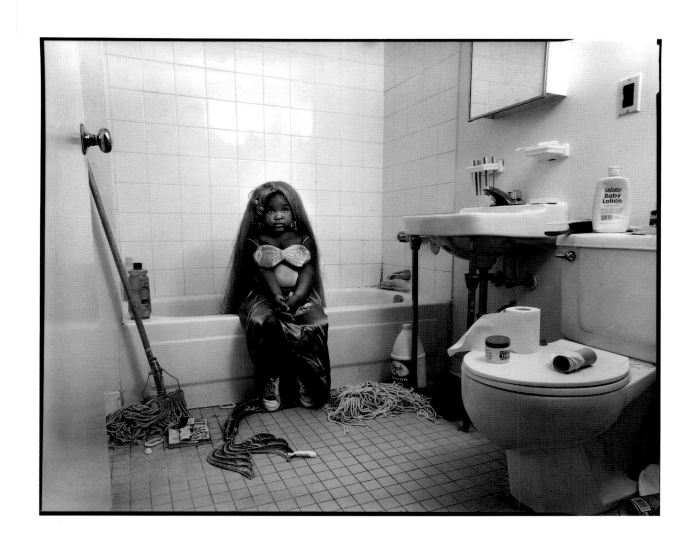

Diamond Settles

Marilyn Salg

I've been to different hells and back. My ex-boyfriend wants me dead. He was trying to kill my son. He threw me down a flight of stairs and beat me up. This is the lowest I've ever been. I used to work at Caldor's as a salesgirl for money. Doing stock, I wrenched my back. Now I have arthritis in my back there, and I'm out on permanent disability.

Elizabeth Sanchez and daughter Melissa Rodriguez

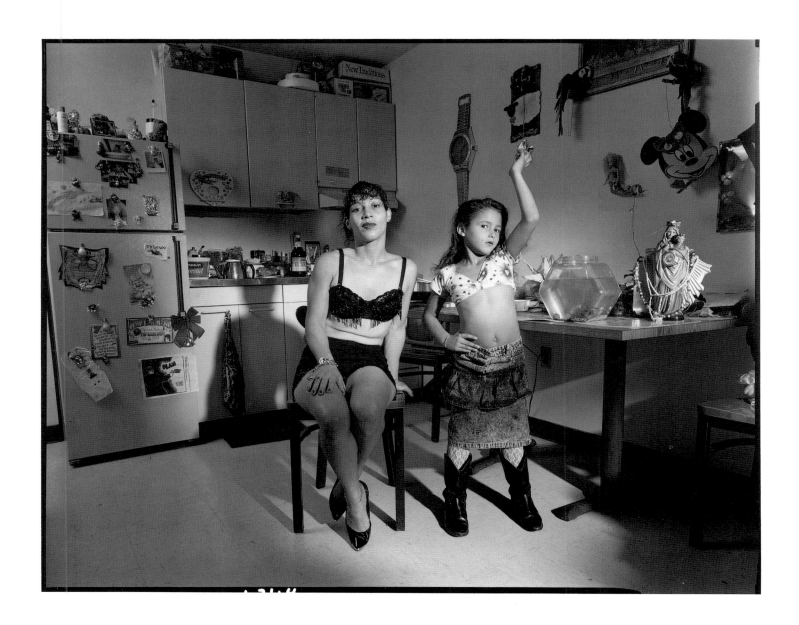

Peter Flores

A place like H.E.L.P. is okay if you use it for the right things. It's not like you come home and have a key. It's not the same as your own home. You're not as comfortable, and it has emotional disadvantages, too. You start getting in trouble if you make friends in a place like this. We've been in other shelters: first we went to Powers. That was a tough place. It's the people that live in these places, not the places themselves, that are tough. That's why we keep to ourselves now.

It's hard to keep up with expenses on a minimum-wage salary. It's hard to pay $700 a month for rent. We were staying with friends, but after a while the friend needed the space again. I was working for Leona Helmsley, but I got laid off. They should have let Leona go. She should have paid a fine to help the city. But by putting her in jail, it took jobs away from people who had nothing to do with it.

I am going to start looking for a job again — now that we've got some help from the system. But I want my daughter Kelly to be a doctor or a lawyer — not a star. Anyway, that's where the money is.

Kelly Flores

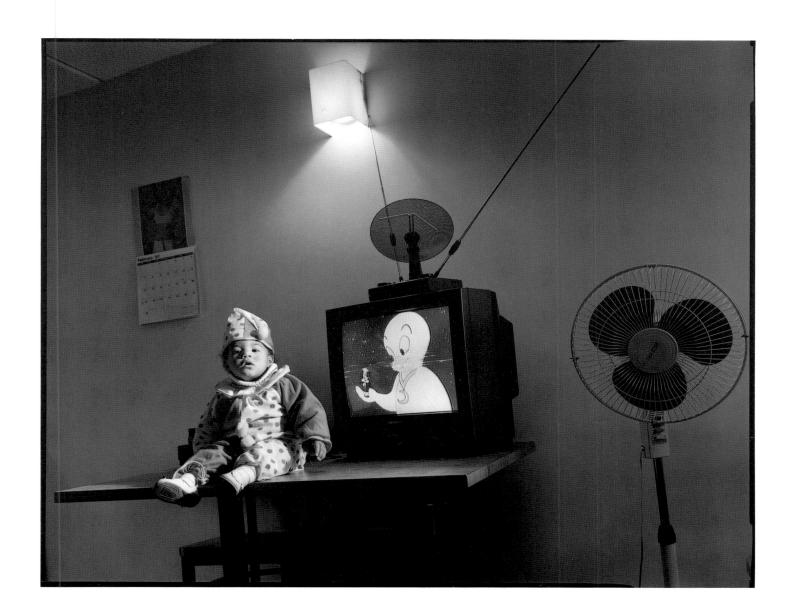

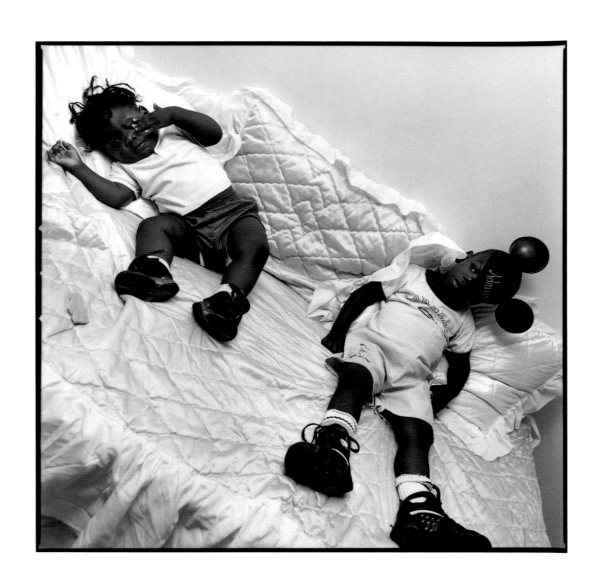

Above: Adam and Andrews "Buddha" Morrison. Right: Robin and Azizuddin Clark

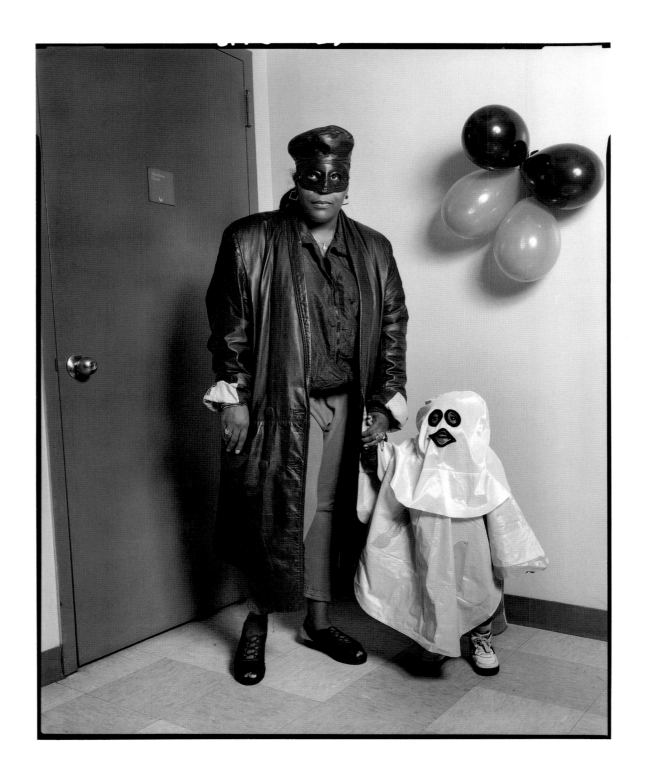

Edgardo Figueroa

I'm on my way to a party, so I've got to talk fast. I'm going to be there all day long. I mean, actually, all night,
until like 3, maybe 3:30, or 4. We're going to hang out, listen to music, eat candy — all that stuff.
There'll be girls there, yeah, of course. My name is Edgardo Figueroa, and I'm fourteen.

I want to mention something about pictures, photographs. They're important, they're like memories.
They bring you back if you look at them fifty years from now. I've lost a lot of pictures in my life. When we moved out
of our old house, in the storage, we lost a lot of things. I've looked for them, but Mom didn't tell me nothing. I don't know
where things went. I was thinking, all those moments — gone. When I realized a lot of things were lost, it's weird.

Anyway, to change the subject, my best subjects in school are social studies, English, and shop.
Basically, I've already decided I want to be a cop. My older sister's in the academy now.

If I had three wishes I'd have lots of money, I'd wish I was an adult already, and I'd wish for peace in the world.
I'm sick and tired of being treated like a little kid.

Look — I'm dressing up as a woman for Halloween. The idea just flicked into my brain. Of course this was only
a one-day thing; it's not like I'm going to go gay. I don't want people mistaking me for a transvestite.

Edgardo Figueroa

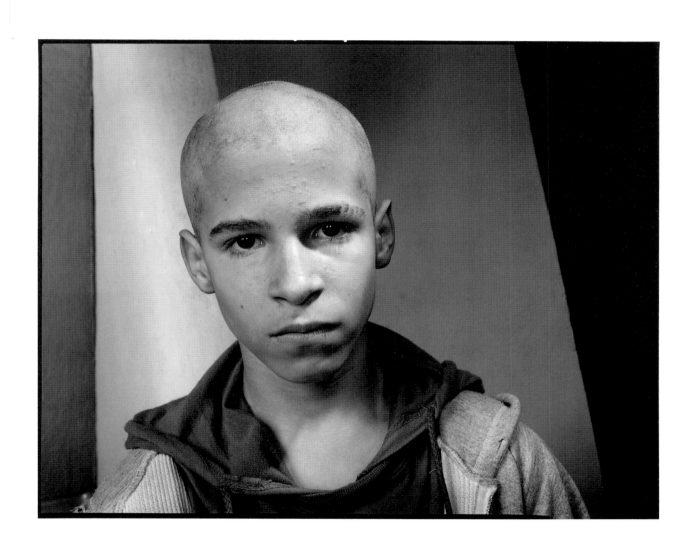

Jennifer Garcia

It's fun to play. It's fun to play with friends. Trust me, if you lived here, you would have lots of fun. In the shelters it's different. The first day you have to sleep on the floor. The second day you sleep on chairs, and the third day, my sister Tawanda (she's seven; I'm nine) couldn't take it any more. She left. We didn't like it. But it's fun here at H.E.L.P. It's nice, better than the other shelter. We have fun with these little kids. I want a baby. But [seeing a sparrow in the yard] I really want a bird. I never had one. [Sigh.] I never will.

Jennifer Garcia

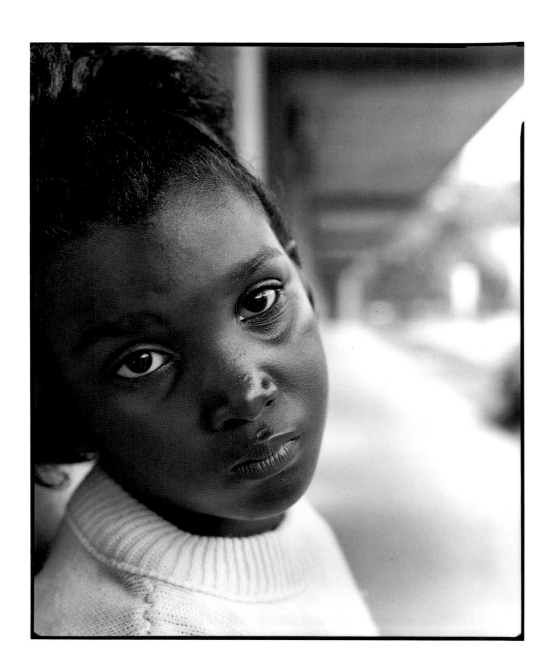

Cheryl Richardson

My son Matthew's a surviving triplet. The other two died. There are some problems here, but we could be in the street. I don't like the curfew, and you can't have boyfriends, but it's better than a bullet going right near my boy's head.

Matthew Richardson

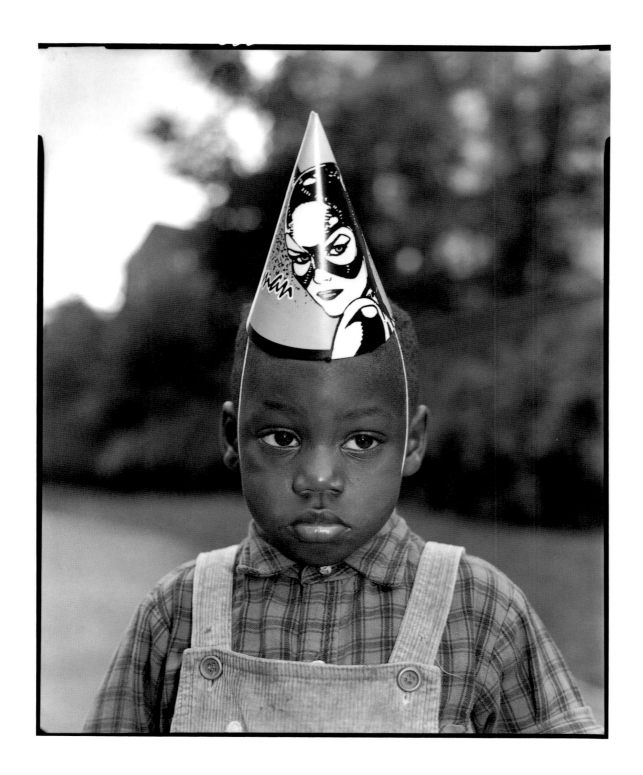

Lynda Tounas

I moved out on him because he started getting a little violent — screaming, yelling, pulling my hair. He tried to commit suicide because I left him, so I gave him another chance. We moved from one motel to another. Me and my husband would be in one room, and my kids in another. We were still not really getting along that well. He said he would get a job but he lied. He said he went to the Chicken-n-Ribs, but he never went there.

He had a Child Protection Services case open, stating that he sexually abused Nicole; someone reported it. I don't think that he did, 'cause when I was there, he didn't touch her. But to ease my mind I decided to go to the doctor to make sure she was alright. The doctor didn't find anything, but my daughter is afraid. It's just funny — why doesn't she want to go near her father?

My friend Betsey James said, "You should get rid of him; he ain't no damn good." I can't give him no more chances, especially with him hurting me. I've got to think of the kids. I've got to provide a good clean home. I moved to my sister's to begin with, but she didn't keep me long. She said, "We've got to find you a safe place to go." Because I had mentioned to my girlfriend where I was and she went and told him. You can't even trust your own friends.

I am afraid of my husband. He still knows where I am. He calls me. I don't trust the man. Being away from him is better. I am growing up more. I'm being independent now — before I'd been depending on him — and really he wasn't much to depend on.

Hector Roman and Crystal McKeller

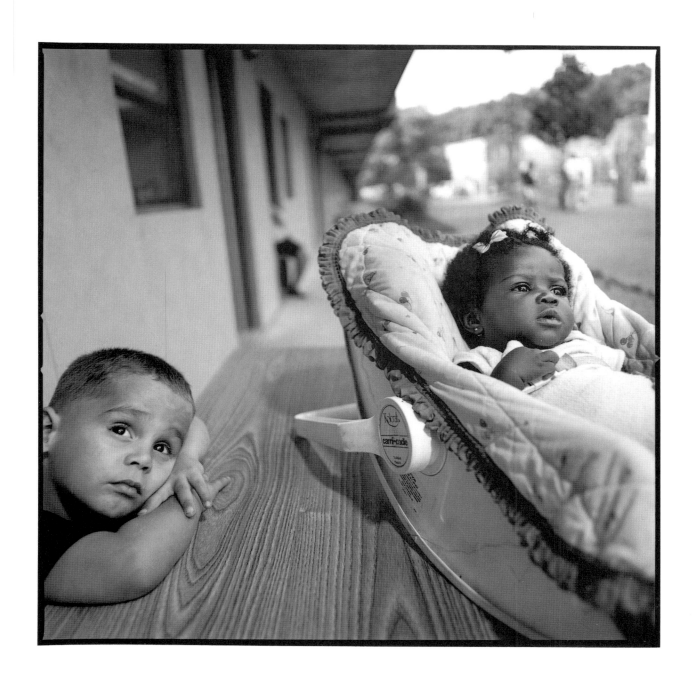

Crystal Joyce

The landlord slapped my daughter in the face, so we had to move. Anyway, it was a bad environment for her. We wanted to kill the landlord. But she is a seventy-five-year-old woman — it wouldn't have been a good idea. We had been living in that apartment for years, but after my son was born the landlord started catching attitude. I don't know why.

I was sixteen when I had my first child. I was working in Burger King and my boyfriend was, too. I worked day shifts with customers and he worked nights in maintenance. I had to stop when I had the baby. Then he got hurt on the job. His back had a herniated disc, so he had to leave. Now he can't find a job at all. I am going to school and can't work till I finish. I am studying to be a medical assistant. They assist in surgery, they take blood, administer medication, help in examining patients — same as a nurse. I would have graduated in May, but I couldn't go back this semester 'cause my car's broke and the school's in Brentwood and I can't go back from January until May 'cause the baby is coming in March.

It was hard to find a place. When we became homeless they first put us in a one-room motel in Hampton Bays. It was disgusting. My daughter had a real bad asthma attack, and there was all this dirt and sand outside, and it was summertime, and there was about forty kids there, with roaches climbing all over the place. The roaches even occupied the toilet seat. All the people there constantly sprayed pesticides and the smell was something, and all the chemicals made us sick. It was a no-win situation.

I got medical statements from the doctors saying that we could not stay there, no way, it was bad for the baby. But still they couldn't move me. I said, well, if I go back there my daughter dies from an asthma attack!

I can't describe what losing your home is like. First, it is annoying having to move all of your stuff. Then you have to put all of your furniture into storage (you can't really take everything with you). Then Social Services doesn't pay regularly — they pay when they feel like it. They will pay three months at a time and then skip the next few months. Then the storage place gets annoyed and then they start selling your stuff. I made a big mistake. I only had two weeks in emergency housing money 'cause I had that other house. So I put everything in storage. And now, everything — everything I own in this world — is gone.

Tony Congema

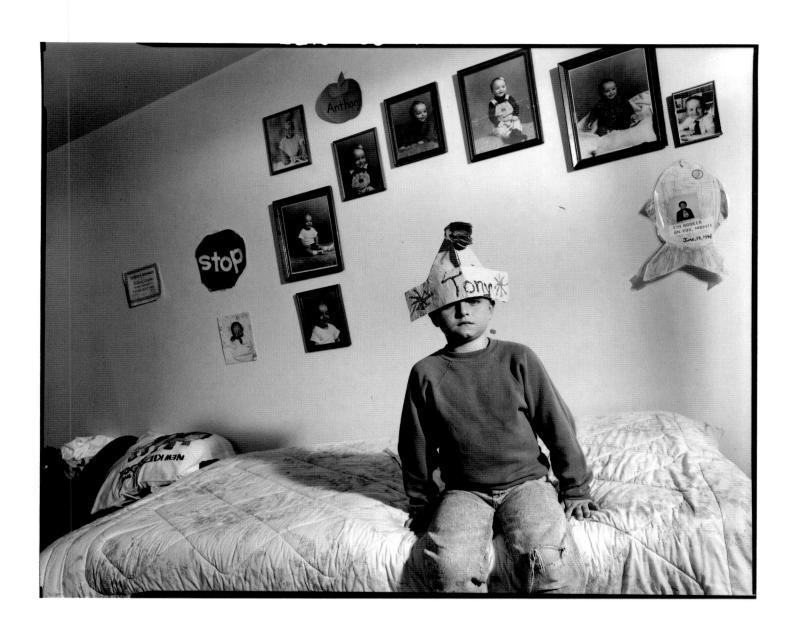

Jennifer Wachenfeld

I have been on public assistance for over one year. I have been bounced from shelter to shelter and every time I find an apartment, Social Services deny it, saying that it is too small, or that it doesn't meet their standards, or they don't want to deal with the landlord. I need Social Services to green light the apartment so I can move into my own place, rather than being in shelters.

I was living with my parents. Things didn't work out between me and my stepfather. I was just getting tired of the rules, there were too many rules at once. I wanted to continue going to school, but the circumstances didn't provide it.

I got pregnant when I was seventeen, and I got married two weeks after my birthday. At first I had an apartment from the money I got from the wedding. Then my husband lost his job. My parents fronted up thousands of dollars for me to survive and I didn't survive. I couldn't keep my job, because of stress. I was in and out of hospital.

Conscious and subconscious are two different things. My subconscious wanted to get pregnant. My conscious said, no, no, no, it's not logical My subconscious was overwhelmed with the fact that I was going to be a mother, because that was my dream when I was in high school — to have my own kids to take care of, not somebody else's.

But I also had another dream and that was the Coast Guard. Maybe if I can get my feet on the floor instead of my butt on the floor, I will go back. I could work on computers and communications, because I had no problem communicating with other people. I like rules now, I go by them, I live by them, because without rule I think there is total chaos. My life has changed a lot. I am learning now how to budget myself, I am learning how to take care of a family, I am learning how to cook. I used to go church and donate — and now I am receiving those donations. It feels very strange.

William and Jennifer Wachenfeld

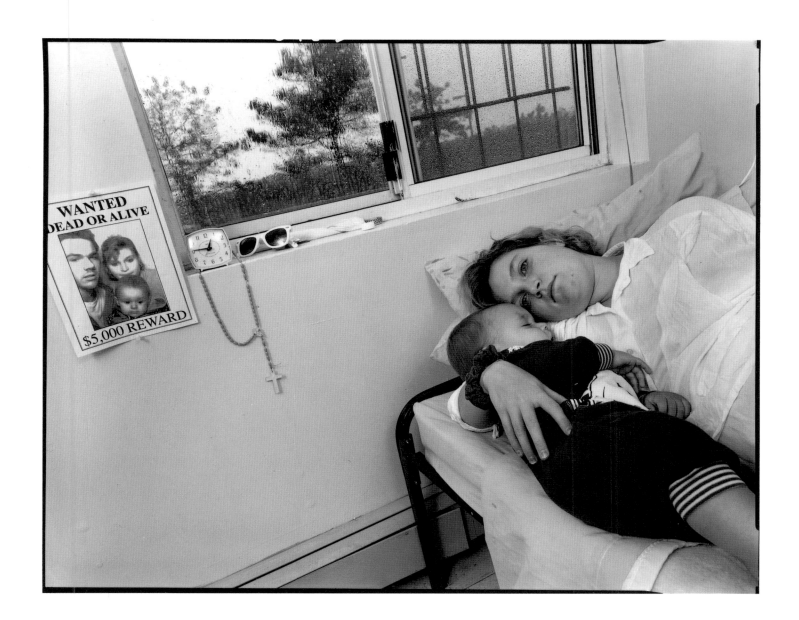

Diane Purificato

Being homeless? I don't even know how to word it. First of all, when it first happens you feel like you have nothing. It's eerie, it's scary.

We were living in a home that was sold by one landlord to another landlord. He decided to gut the house and so he evicted us. We didn't find another home and that is how we ended up here. I actually kind of like it here. I mean, you hear hell stories about emergency housing and it was really scary. One house that we had looked at in particular had a man standing on the corner with a cellular phone, and you know what that means: drugs. I did not want my children in that environment.

I'd rather raise my children myself. My daughter is not set in her personality and ways yet, and I'd rather be there for her. Joey, my son, is set in his ways and now I wanted him to start getting ready for school, get him used to a schedule.

I used to work in Woolworth's. I started working after I got pregnant even though I didn't know I was pregnant. They didn't give me maternity leave because I started working when I was two-to-three months pregnant even though I didn't know it. I was making $187 a week.

My husband grew up with his mother, who was of German descent, and my husband understands and speaks German. Their great-grandmother is half-Greek and half-Indian; she looks like an gypsy. How can people say that the blacks don't belong here, and speak up for white supremacy and everything? I go by people, not by race. What I believe is that none of us really belong here. The Indians are the ones that belong here. There shouldn't be all this racial stuff going on here, because we all don't belong, except for the Indians who were here in the first place.

I just want my children to live happy lives. Hopefully, they won't be in the same situation that we are. At this point, I really don't have any set wants for them, because I don't know how much I can give them at the moment. I just have to see how it goes from here.

Joey Purificato

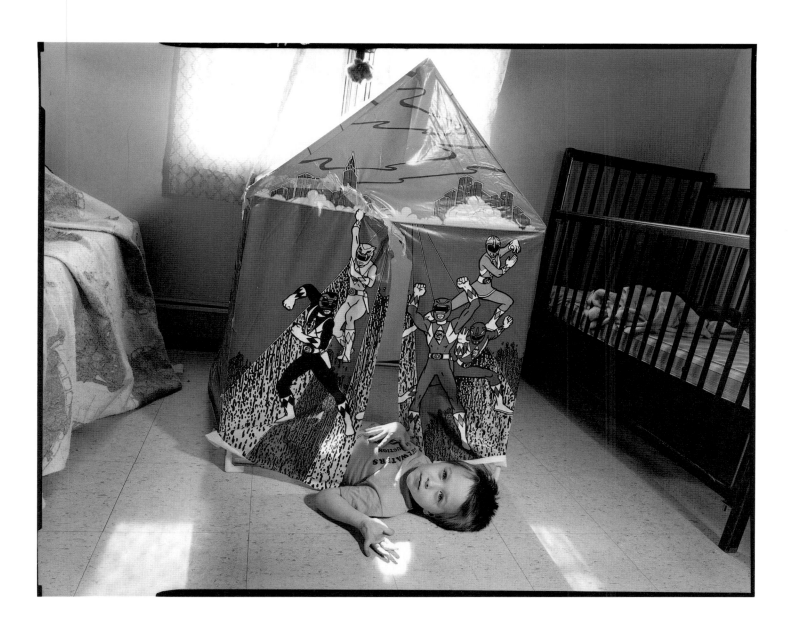

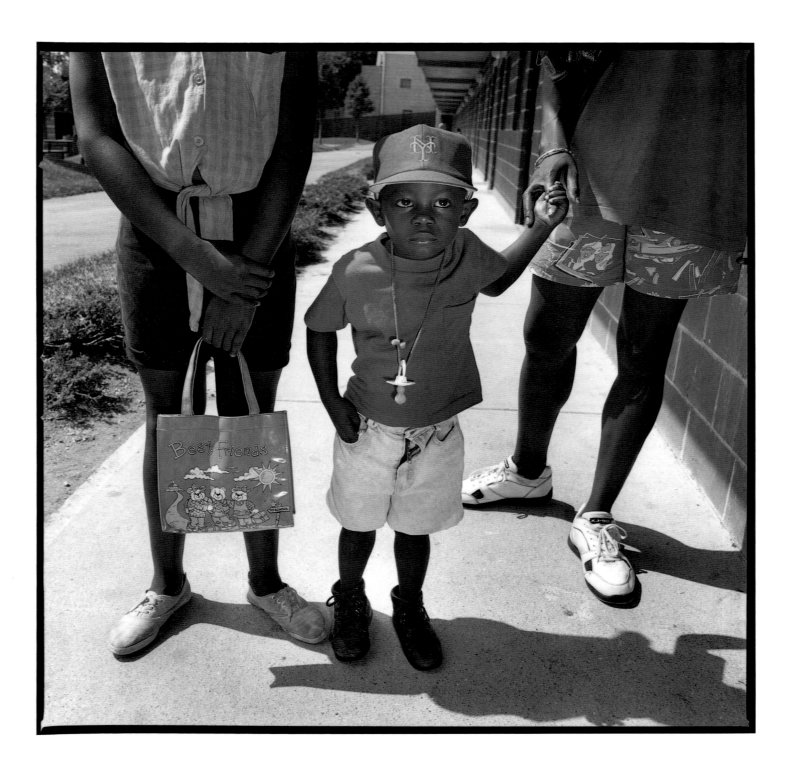

Cathy Fernandez

I married him because I needed a husband and father for my children. He was Mr. Wonderful for a year, and then things started happening. He isolated me. He didn't want me having friends. He didn't want me working. He would get jealous of me making macaroni and cheese for my son. He even told the kid after a few years we were together he hated his f—ing guts. I always protected my son because I felt my son needed me. And I just sat back and felt bad for my kids because this man hated my kids. He always wanted sex and I wasn't up to that because I started to feel hate. Now my son is fourteen. He wants to get a gun and kill that man. My daughter says she wants to die; she doesn't want to live. I mean, she's eleven years old.

Now look at me. I'm in a shelter. I have bills and bankruptcy. I've gone through a divorce. He sits there and laughs at me and says, "Ha ha, you never had a job. I have money." I have a two-year-old son from him. I have nothing.

Matthew Burke

Mashon Baines

Homelessness could happen to anyone. When you have nowhere to go, you have to go somewhere. One main way to get housing is to get on the politicians. We have too many homeless people. I have registered people to vote. If you want to find something decent, you have to get out there yourself. No one's asking for luxury or something extra, but you expect a certain quality when you have kids.

No matter how much of a bad experience people have had in the system, they still do see hope, and are willing to participate. I try to push people to look out for each other here. We can still make it. Life is still what you make of it, and only the strong do survive. Encouragement is very important. It helps keep you going. With three small children, it's very hard. I want to push for proper daycare and adequate housing, education, food, and shelter. There is no excuse for us not to have these necessities. You would expect people to give up on people on drugs or low-lifes with a ghetto mentality, but a lot of people here aren't like that. But look at our generation. There's no middle line, family structure is not together. No one is with their biological father. This is a single parent generation. No one was taught how to be a responsible father. They forgot to teach us how to be a mother, the basic things of domestic life, like how to cook and clean. Children are forgotten, and we're lost, especially in New York City. It's so fast, such a fast life. We weren't taught it's a hard responsibility.

I like people. I care for people, not black or white, just people, especially children. Everybody needs somebody sometime. If I have it, I give it. No one should starve.

Keyona and Mashon Baines

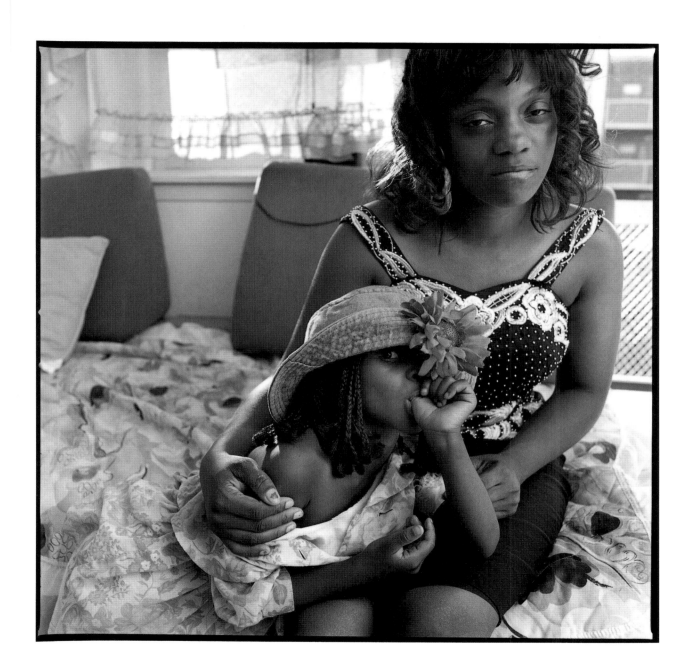

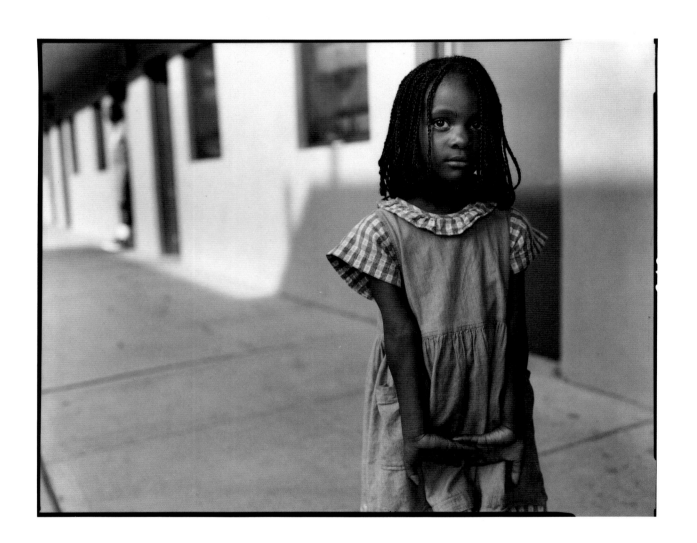

Keyona Baines

About H.E.L.P.

When I became homeless, I was scared. They could have sent me anywhere. Believe me I prayed. I spent six days in that E.A.U. [Emergency Assistance Unit] office with my children, sleeping there. I told my children that we need to stick together and pray and believe that we are going to get the best. When they found me this place, I knew there was hope. You couldn't ask for better. I told my children when we arrived here that night in February, "Tell me, do you ever doubt God? 'Cause look at this. It's beautiful." There is hope, if you believe.
 Milagros Vega

After a careful study in the mid-1980s of national housing initiatives and social policy regarding the homeless, Andrew Cuomo, today Assistant Secretary for Community Planning and Development of H.U.D., proposed an innovative alternative to the inhumane warehousing of homeless individuals and families in welfare hotels and emergency shelters.

In 1986, Andrew Cuomo founded H.E.L.P. (Housing Enterprise for the Less Privileged), creating a model to deliver care for the homeless more effectively and to utilize government resources more efficiently. Its unique platform of public-private partnership made H.E.L.P., after a decade of service, the largest designer and developer of homeless housing and services in the United States. It became the model for New York State's system of supportive, transitional homeless family care. In fact, for the last decade, New York State has been the only state in the nation with a funded system of care for homeless families, and reports only a 5% recidivism rate.

Today H.E.L.P. cares for over 1,000 families a day, operating ten family residences that have been recognized with awards for architectural and design excellence. The program was also named a national demonstration model by the United States Congress in 1988. All H.E.L.P. residences are designed to restore dignity to homeless families by replacing shelter living with private apartments and interior and exterior community space. Through creative planning, tight expense control, and designed economies of scale, H.E.L.P. has been able to offer housing with support services at less than seventy percent of New York City's cost to house a family in a welfare hotel.

For homeless families, day-to-day life is a struggle. Today H.E.L.P. is working with cities and states nationwide developing and implementing initiatives to address the needs of a growing number of Americans in need of shelter and human services. There is widespread agreement between private sector, public sector, and human service providers on the effectiveness of H.E.L.P.'s national model of a holistic continuum of care for homeless families with special needs.

H.E.L.P.'s children and parents participate in an independent living program custom designed with site-based professional staff to address their (often multiple) needs. These can include case management, day care, medical care,

therapeutic recreational programs, parenting skills classes, mental health counseling, drug and alcohol screening and prevention, teen pregnancy prevention, AIDS awareness, vocational and educational assessment, job training and high school equivalency education, and housing counseling and placement. H.E.L.P. cultivates an extensive network of linkages with local human services providers as well, to ensure ongoing support for families once they reside in permanent homes.

 The necessity of providing permanent supported housing for homeless families, along with the great demand for community revitalization, prompted H.E.L.P. to create Genesis, a program of permanent affordable apartments with support services. At Genesis residences, families graduate from transitional facilities and live together with working families, sharing on-site community-based programs including day-care, medical care, and an array of special services developed by Genesis tenants and administered with the assistance of on-site professional staff. Like H.E.L.P.'s facilities, Genesis apartments are architectural and social enhancements to their communities. Both share the mission of empowering families and individuals to lead independent, productive lives by practicing the principle of prevention before intervention and helping individuals help themselves.

 As the largest providers of housing and services to homeless families in the United States, H.E.L.P. understands the many complexities of this disenfranchised population. Each year we have seen this group grow, as economic, cultural, social, and political attitudes and policies work against families and individuals. H.E.L.P. has also learned that with wise investment in prevention and education, individuals caught in the cycle of poverty can lead independent, healthy lives. After 10 years of service working with thousands of families who have achieved self-sufficiency, H.E.L.P. remains committed to working together with the public and private sectors to create opportunities to improve the quality of life for those in need.

The following are H.E.L.P.'s current facilities: H.E.L.P. I; H.E.L.P. Bronx; H.E.L.P. P.S.I.; Genesis Homes; H.E.L.P. Albany; West H.E.L.P.; H.E.L.P. Suffolk; Genesis Apartments at Union Square; H.E.L.P. Haven; The H.E.L.P. Prenatal Center.

ACKNOWLEDGMENTS

This book would not have been possible without the gracious cooperation of H.E.L.P.'s residents who shared their personal stories, and the generous support of Joanne Leonhardt Cassullo and The Dorothea L. Leonhardt Foundation, Inc.

Sincerest appreciation to Mary Ellen Mark, whose brilliant talent and insight captured the true experience of the children and families caught in the cycle of poverty.

H.E.L.P.'s national model of housing and human services for the homeless depends on the leadership and support of many individuals in both the public and private sectors. We would like to thank the following for empowering the homeless to live independently:

Governor Mario M. Cuomo, Mayor Edward Koch, Mayor David D. Dinkins, and Mayor Rudolph Guiliani
Jerry I. Speyer & Tishman Speyer Development, and Alexander Cooper & Cooper, Robertson, Ltd.
H.E.L.P. founder Andrew Cuomo, the H.E.L.P. Board of Directors, Advisors, supporters, and volunteers.

Our greatest appreciation goes to the H.E.L.P. staff for their dedication and tireless effort in improving the lives of others, with special acknowledgments to: Marc Altheim, Megan Brewster, Susan Cahill, Lisa Lombardi, Tom Mauro, Jennifer Heller Monness, Richard Motta, Nancy Nunziata, Dennis Power, Vincent Ravaschiere, Jeannette Ruffins, Richard Scantelbury, Fred Shack, Migdalia Soto, Claudia Stepke, Laurie Tucker, and Cynthia Wade.

Maria Cuomo Cole
September 1995
New York, New York

Sixty percent of the homeless in America are children. In them I see the anxiety of impermanence. They never feel secure. Their toys and clothes are packed in boxes that get lost or are never opened. The rooms they live in are often barren. This book is dedicated to those children.

I am so grateful to Maria Cuomo Cole and Joanne Leonhardt Cassullo for giving me the very special opportunity to produce this project. I want to thank the John Simon Guggenheim Foundation for their additional generous support of the work. Thank you to Victoria Kohn for her dedication, hard work and excellent reporting. Her genuine interest in the children made them love and trust her and enabled her to collect many of their most profound thoughts. I could not have done these photographs without Victoria. Thank you to all the executive directors and staff of the H.E.L.P. facilities, at Crotona Center, Susan Cahill, Jeanette Ruffins, Migdalia Soto, Richard Scantlebury; at Suffolk, Nancy Nunziata, Laurie Tucker; at Westchester, Dennis Power, Cynthia Wade, Patricia Epps. They believed in the project and gave me total access to their facilities. Most of all I would like to thank the many families that live in the H.E.L.P. shelters for welcoming us into their homes and sharing their lives with us.

Special acknowledgments also go to Martin Bell; Catherine Chermayeff and Nan Richardson/ Umbra Editions; Stefani Cunningham; Michael Darter; Grant Delin; Jeff Hirsch/ Fotocare; Peter Howe; Laurie Kratochvil/ Visa Pour L' Image; Jean Francois Leroy; Mark Morosse; Leslie Nolin/ The Museum of the City of New York; SinarBron; Brian Velenchenko; Anna Wintour/ Vogue Magazine; Sandra Wong; and to Sarah Jenkins, Leslie Yudelson and Jessica Bryan — thank you, as always, for your beautiful prints.

Mary Ellen Mark
September 1995
New York, New York